painting
CLOSE-FOCUS
FLOWERS
in watercolour

Ann Pember

BATSFORD

About the Author

Ann Pember is a signature member of Audubon Artists, Knickerbocker Artists, USA; National Association of Women Artists, Inc.; Catharine Lorillard Wolfe Art Club; Watercolor West; and many other societies. She has had work included in more than one hundred juried, national exhibitions and is the recipient of numerous awards. In 1968 she received a BFA from the Massachusetts College of Art in Boston with a major in fashion design and illustration. She has studied watercolor with many fine painters. In 1980, following a twelve-year career in commercial art, she began painting full time in watercolor. Her work has appeared in numerous books and publications and is included in private and corporate collections throughout the United States, Canada and Europe. In addition to her regular painting schedule, Ann teaches workshops in watercolor for beginner to advanced students.

Ann shares her home on Lake Champlain in the Adirondack region of New York with her husband, Jay Frank, and their Himalayan cats, Kato and Tasha.

© 2001 by Ann Pember
First edition

A catalogue record for this book is available from the British Library.

Printed in China

First published in the United Kingdom in 2001 by

B T Batsford Ltd
9 Blenheim Court
Brewery Road
London N7 9NT

ISBN 0 7134 8673 2

A member of the Chrysalis Group plc

Dedication

Dedicated to my husband, Jay, who has always encouraged and supported my artistic pursuits. Also to my parents, Kay and Alden Pember, who allowed me the freedom to take an artistic path, and to my faithful companion cats, Kato and Tasha.

Acknowledgments

Sincere thanks to Rachel Wolf, with whom I've worked before, for suggesting the idea for the book and proposing it to the publisher, and to my editor, Jennifer Lepore Kardux, for her support, guidance and expertise. Also to designer, Wendy Dunning, for pulling everything together so beautifully.

My gratitude goes to the many art instructors and watercolour painters who have come into my life and inspired me.

Thank you to my family, friends, patrons and students for their enthusiasm and support.

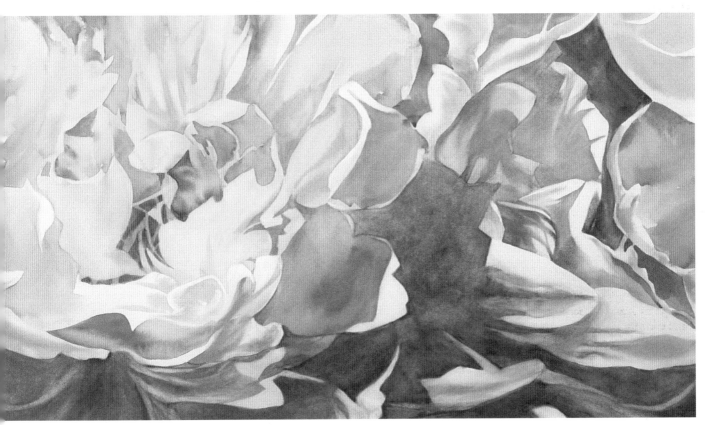

PEONY RHYTHM
Waterford 140-lb. (300gsm) cold-pressed paper
15¾" × 29½" (40cm × 75cm)

Table of Contents

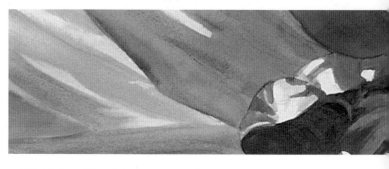

Introduction: My Philosophy ▪ 8

PART ONE

The Practice of Painting ▪ 10

▥ What Moves You to Paint Flowers? ▪ 12

▥ Flower Sources ▪ 14

▥ Studio Setup ▪ 16

▥ Choosing and Handling Your Materials ▪ 17

▥ Mixing Luminous Color ▪ 22

▥ Painting Methods ▪ 28

▥ Mingling Colors ▪ 30

DEMONSTRATION
Mingle Colors: Hollyhock Bud ▪ 32

▥ Vary Edges ▪ 34

▥ Texture ▪ 36

▥ Lifting Techniques ▪ 38

▥ Create a Pattern With Flower and Bud Shapes ▪ 39

▥ The Character of Petal Shapes ▪ 40

DEMONSTRATION
Flower Clusters: Backlit Phlox ▪ 41

▥ Flower Centers ▪ 44

DEMONSTRATION
Painting Flower Centers: Rhododendrons ▪ 45

▥ Consider the Background ▪ 46

DEMONSTRATION
Background Foliage Patterns ▪ 48

DEMONSTRATION
Integrate Background Foliage With the Flower: Hydrangea ▪ 50

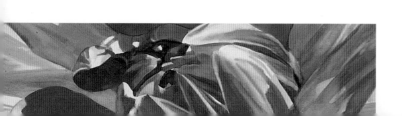

▦ Consider the Lighting ▪ *52*

▦ Designing Your Composition ▪ *54*

DEMONSTRATION
See and Paint Simple Shapes: Begonia ▪ *58*

DEMONSTRATION
Value Sketch: Rose ▪ *60*

▦ Try a Limited Palette ▪ *62*

DEMONSTRATION
Paint in Two Colors: Pink Phlox ▪ *63*

▦ Tone the Paper Before Painting ▪ *66*

▦ Try Painting on a Smooth Surface ▪ *68*

DEMONSTRATION
Practice Loosening Up: Rhododendrons ▪ *70*

PART TWO

Assemble the Pieces: Step by Step ▪ *72*

DEMONSTRATION
Getting Started Painting Close-Focus Flowers: Amaryllis ▪ *74*

DEMONSTRATION
High-Key Floodlight Effect: Hollyhock ▪ *78*

DEMONSTRATION
Backlight Effect: Peony ▪ *90*

DEMONSTRATION
High-Contrast Spotlight Effect: Gladiola ▪ *100*

DEMONSTRATION
Painting on a Smooth Surface: Lotus ▪ *110*

Conclusion ▪ *120*

Glossary ▪ *121*

Gallery ▪ *122*

Index ▪ *126*

Introduction: My Philosophy

Painting flowers in transparent watercolor is a fun and challenging pursuit. I hope you will share my enthusiasm for this wonderful medium and this inspiring subject. For me, the shapes, light and colors are most important. I especially like the abstract patterns formed by petals and foliage.

My Background

I began drawing in early childhood and experimented with watercolor, oil and pastel in school. Luckily, I was always encouraged by family and teachers and knew I was to have an art career. In college I experienced silk screening, sculpting, metalwork, ceramics and textile design. There was much emphasis on figure drawing, and I began to feel drawn to watercolor over the other mediums. After college I produced fashion advertising for Kennedy's, a clothing store in Boston, where I had done an internship. Then I moved on to design greeting cards, wrapping paper, small books and gift items for Rust Craft Greeting Cards. Once familiar with the field, I continued in this work, doing freelance art for numerous companies, including Gibson and Buzza Greeting Cards, The Paramount Line and Milton Bradley. During this period I worked with watercolor, gouache and inks, becoming more comfortable with the liquid mediums. In 1980, after twelve years of making art for others, I left commercial work behind and began painting in watercolor full time. I took workshops, studying with many gifted painters. I also amassed a library of art books, including how-to-paint versions by some of my favorite painters. My present painting style and techniques reflect these various influences, and I am grateful to all those whose works and words inspired me.

Using This Book

Many of the exercises and techniques in this book are borrowed or based on what I've learned from others. It is filled with methods and ideas I have explored that work for me and my students. I urge you to try the exercises and be open to new ideas. Don't just flip through, looking at the images. I hope you will find at least one idea to experiment with. As with all things, practice pays off. I wish there was a quick, easy approach to painting well. There isn't; it comes from setting goals and working steadily toward them. The more you work, the faster you'll progress. We all start at different levels of ability and have various talents, so some will grow more quickly than others. Be assured, you will grow if you do the work. The most important thing to remember is that we never stop growing. That is exciting!

Develop Your Own Style

Art is the expression of one's personal feelings about a subject. Heartfelt emotion is what gives the work life. Techniques allow us to translate it to paper, but are not meaningful themselves. It is important to give your paintings a personal touch that is yours alone. Copying another artist's style can be a great learning experience, but you will never have the benefit of their individual life experiences and influences. Without actually being them, your work may look the same, but will always lack something: usually integrity and emotion. Pursue your own form of expression. Even when inspired by another artist's style, you will have your own way of touching the paper. Paint subjects that move *you*. Choose colors *you* respond to. Make art from the heart. What draws you to paint flowers: colors, textures, shapes, memories, atmosphere and light, perspective? Explore these aspects as a way to individualize your work.

Don't settle for making pretty pictures that are photographically correct, but lacking in feeling. A camera captures everything, but a painting can translate the spirit of the subject and edit the unnecessary elements. Invent your own symbols and language. Be willing to take risks in your work. Look upon mistakes as steps in your growth as an artist. They are a necessary part of the journey. Enjoy the process and don't take it too seriously!

Keep It Simple

There are many aspects, techniques and approaches to painting. It might prove helpful to you, as it did for me, to simplify everything. (Simplifying all aspects of your life is a worthy challenge and is very liberating.) Choose a medium and a favorite subject and concentrate all your efforts on them. Even simplify your palette and the tools you use. It is possible to produce beautiful work with only one brush and two or three tubes of paint! Sometimes we get bogged down with too many interests or techniques, or even too many tubes of paint or brushes. Limiting your choices will allow you to concentrate on the important issues of composition, color, light and other elements of design. As you proceed through the book, remember to keep it simple. Above all, have fun!

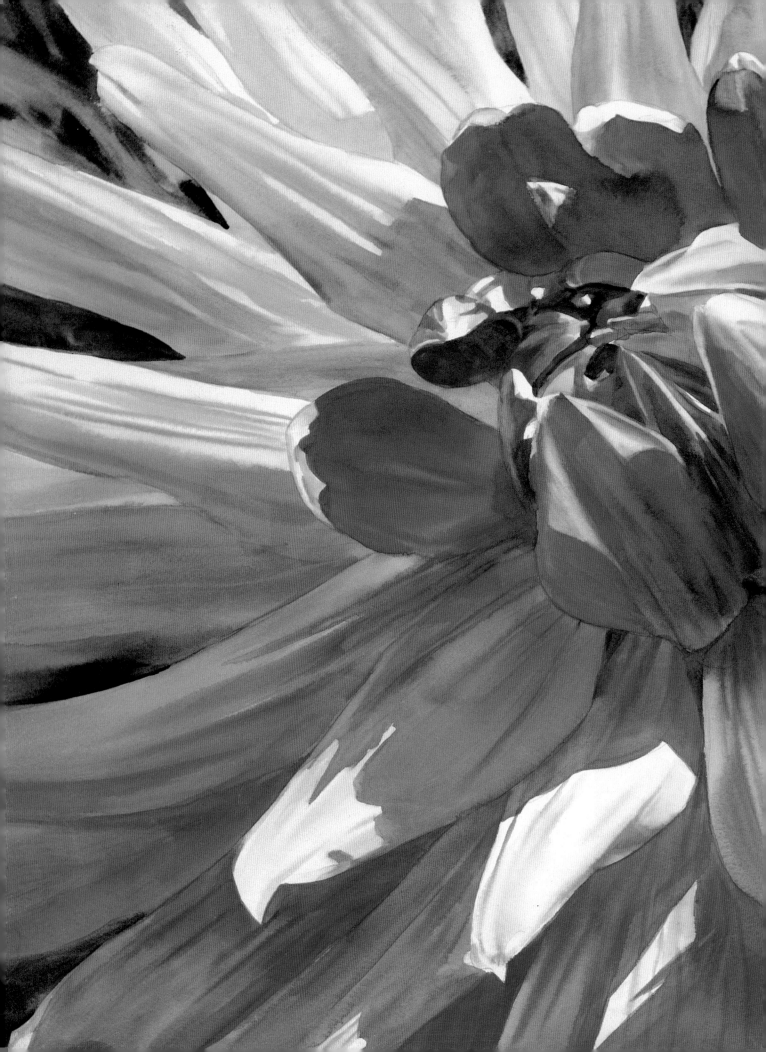

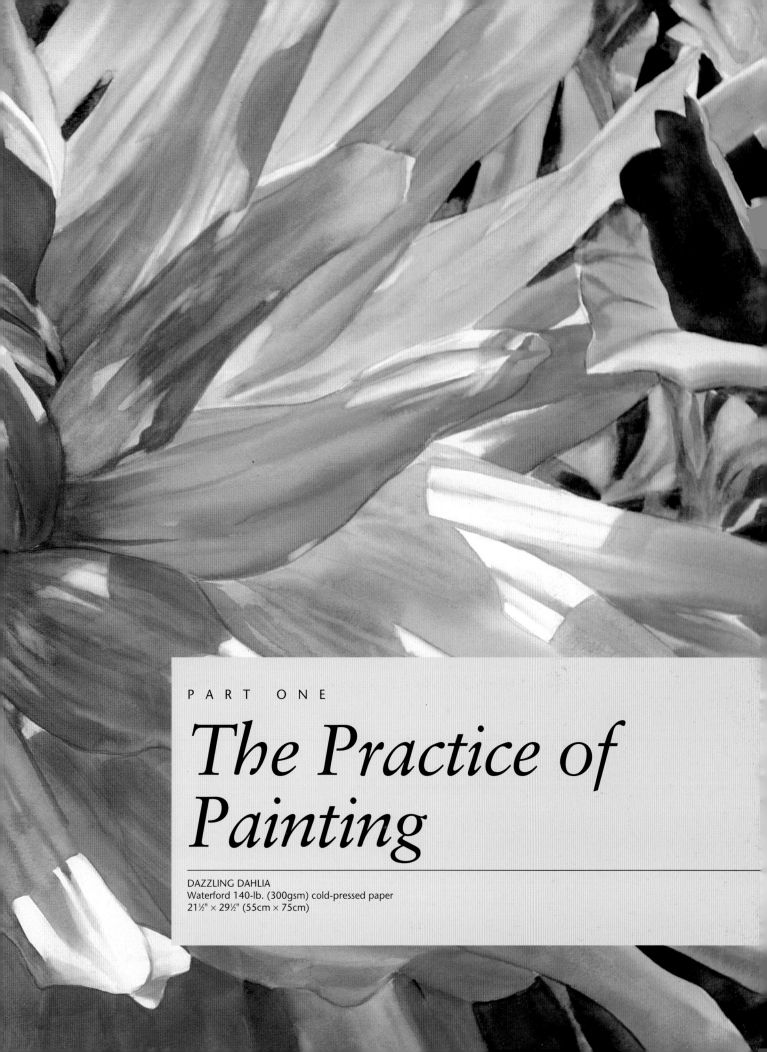

The Practice of Painting

DAZZLING DAHLIA
Waterford 140-lb. (300gsm) cold-pressed paper
21½" × 29½" (55cm × 75cm)

What Moves You to Paint Flowers?

Flowers have been a popular painting subject for centuries, from tight botanical rendering to the most abstract suggestion. I'm guessing you chose this book because you love flowers. An emotional involvement with the subject is an important starting point for painting and will be reflected in your work. Choose flowers that appeal to you, and find an aspect of them on which to focus.

Why I Paint Flowers

I have been a gardener since childhood, when I was inspired and encouraged by my grandmother. Helping her tend a variety of flowers gave me a sense of connection to the earth. Nature has been my inspiration and a constant source of joy ever since. Even the collection of gloxinias she kept in her bedroom moved me. It seemed miraculous to

me when they came back into bloom each year, after appearing almost dead. To this day, I always have at least one gloxinia in the studio, a lovely reminder of the past and a worthy subject whenever in bloom. This reverence for nature and a higher power defines my paintings, and I hope it touches the viewer of my works as well. I look forward to painting my favorite flowers as each variety comes into bloom. I respond to the essence of the flowers by painting a suggestion of their image, as if parts of them are out of focus. Though somewhat abstract, my paintings still appear realistic. I usually choose my subject for the shapes of the petals under various light conditions and for their subtle, beautiful colors. I do not feel the need to reproduce them exactly; my photos do that.

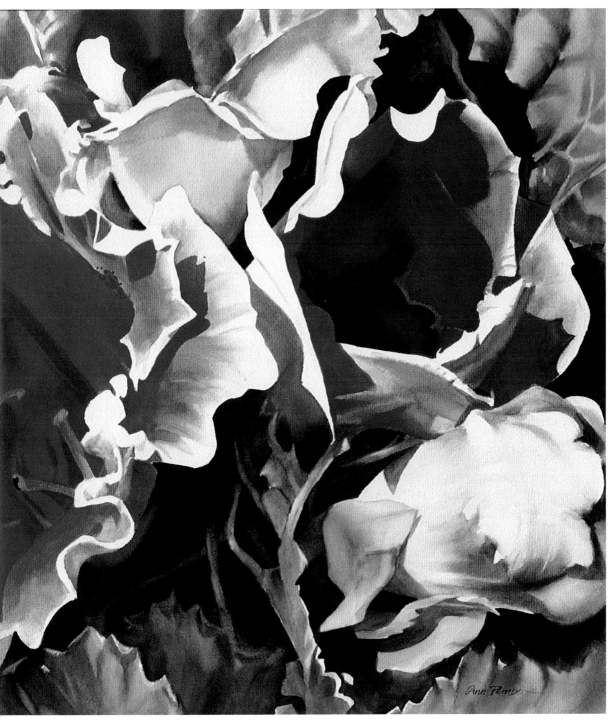

GLOXINIA GEMS
Arches 140-lb. (300gsm) cold-pressed paper
28" × 36" (71cm × 91cm)
Collection of Trini and Jean-Ives Folliot

Flower Sources

If you don't have a garden, there are many other sources for flowers. Go to botanical gardens or take garden tours. Maybe you know someone with a great garden you could visit. My friend Mina always lets me know when her magnolia is ready to bloom. It is a wonderful opportunity to gather new reference photos and sketch with a friend. Attend flower shows, and visit garden centers and flower shops. Bring a camera and sketch pad. Order yourself a beautiful bouquet—you deserve it! Make it an exotic one for interesting shapes to study.

Most importantly, draw flowers, observe them. Become familiar with how different varieties form, what kind of stems and foliage they have and how changing light affects their appearance. Look for the kinds of patterns they create. Try gesture and contour drawings of flowers, then try simple paintings of them. Try to make your statement with mass, concentrating on the general shape and gesture. It will help if you understand the structure of the flowers. Careful observation will give you this knowledge; botanical training is not necessary. You can treat this subject in countless ways: You might emphasize the light, middle or dark values, use nontraditional colors, play with different types of lighting, change the viewpoint, etc. I zoom in with a close viewpoint to take advantage of the patterns of shapes and values. Have fun exploring many treatments.

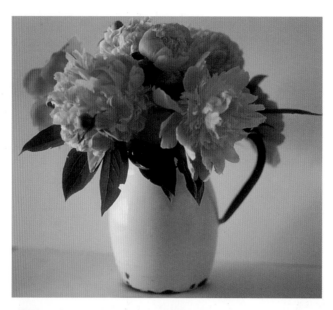

A traditional composition with a distant point of view.

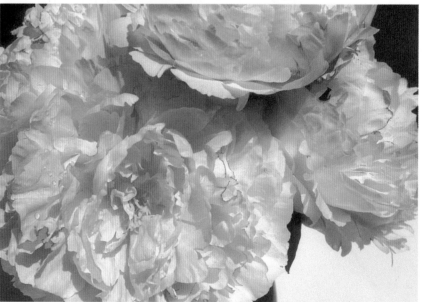

A close point of view simplifies and abstracts the design.

Photo Tips

When photographing flowers, it helps if you use a good 35mm SLR (single-lens reflex) camera with a macro, or close-up lens, to take advantage of the abstract nature of flowers. This allows you to get in very close and reduces the amount of editing later. Keep a file of photos for each variety of flower. Think of the overall shapes as you frame your shots, simplifying even this. Notice the lighting and move around to get the most interesting view. Don't try to include too much. Keep your statements simple, whether using the camera or painting. The lighting at noon is most direct and will light the top of everything. It can be harsh on a clear day, washing out the colors. On a more atmospheric day, the subtle colors will be visible. Early morning and late afternoon light produce longer shadows and are my favorite times to photograph.

Editing Photos

When planning a painting, you can use small mat corners to edit the photos you've chosen. I usually edit quite a bit and may take pieces from several photos. As you do this, take care that the lighting is consistent and make any necessary changes. You can cut out parts of the photos and glue them together the way you want, and you can paint on them to add or eliminate elements. Use some gouache mixed with watercolor so the paint adheres to the slick surface. This is one of many ideas I learned from Judi Betts, with whom I've taken several very informative workshops.

Overlaid photo cut to fit the design

Painted areas

Main photo

Overlaid piece of photo

Painted areas

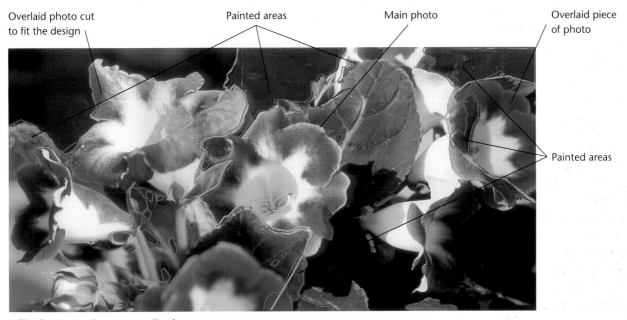

Edit Photos to Compose a Design
Here I've cut out elements and glued them together. Then I made further changes by painting on the collage with gouache mixed with watercolor.

Studio Setup

I have become a studio painter. Although I still enjoy going outside to sketch, I prefer the convenience of my studio setting for serious work. There I have good lighting and everything close at hand, just where I want it. I need not fight the weather, bugs or changing light. It is important to become totally involved with your subject. My time in the garden is my observation time, when my emotion about pet plants takes over. This stays with me and is easily recalled when I begin looking at reference material to plan a painting.

Claim a Workspace for Yourself!

My workspace is a fairly large studio addition that we built in 1993. It measures 17' × 22' (5m x 6m) and has many large windows and three skylights. It is also equipped with daylight spotlights, so I can work at night.

It's great to finally have proper tools and storage for everything, but you can manage quite nicely with a simple table and easel. Claim a spot for yourself if you haven't already done so. It will put you in the mood to paint whenever you go there. Even a closet is a possibility!

Try Working on a Tilted Board

I use an easel that adjusts from vertical to flat. It also adjusts in height, so I may work seated or standing.

I prefer the results of painting vertically to those of painting flat. When working flat there is much puddling and more likelihood of making mud. With the paper tilted, gravity makes the paint move and mix, producing lovely passages of color. Though at first it may seem hard to control drips, after a few experiences you will learn how much water and pigment to use to gain control. It's almost like pouring paint on a wet surface. I think it helps give a fresh look to the work. Try at least a moderate angle to get your paint moving. I started by placing a 2×4 (5cm × 10cm) piece of wood under the upper edge of my board on a table.

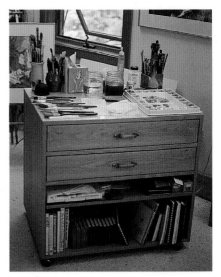

Taboret
This taboret holds my painting equipment. I designed it from a wooden kitchen cart. It has a washable Formica top, two drawers and an open space with an adjustable shelf. It measures 32" (81cm) long by 29½" (75cm) high by 24½" (62cm) deep and is set on casters for ease of movement. The storage shelves on the bottom hold sketchbooks and extra supplies, and the two drawers hold paint and reference material.

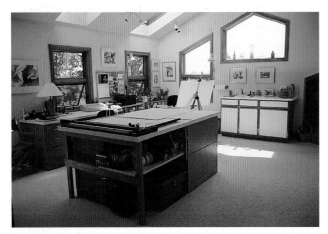

A view of my studio showing the cutting table where I frame, and the sink on the far wall. A flat file serves as the base for the cutting table.

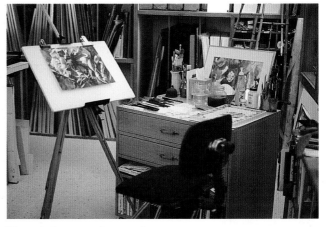

The painting area of my studio.

Choosing and Handling Your Materials

The most important consideration when purchasing materials is to use the best quality paper and paint you can afford, and use brushes that hold a clean knife-edge if flat or a fine point if round.

Paper

There are many variables in watercolor papers, including: weight (thickness), how it was made (machine-made, moldmade or handmade), sizing (a coating that makes the paper resist fluid; may have interior or exterior sizing), and form (sheets, board or blocks). I prefer a rag paper that resists buckling and allows easy lifting. My favorites are 140-lb. (300 gsm) or 300-lb. (640 gsm) cold-pressed paper (Waterford, Bockingford or Arches brands). I also use Strathmore 500 Series high plate bristol board, which has a very slick surface (see pages 68-69 and 110-119 for more information).

Purchase a trial pack with one sheet of several different papers. Materials can be very personal, so try supplies like paper firsthand to see what feels most comfortable to you.

When handling paper, be careful to just lightly hold the edges. Pressing down with your fingers leaves oils that may repel paint and leave a mark. If you soak and stretch your paper, use only a soft natural sponge without any sharp pieces of coral in it. Dust dry paper off with a soft 2- or 3-inch (51mm or 76mm) brush before beginning to paint. This gets rid of any dust particles that may dry into a wash.

Backing Board

I used to soak and stretch paper, but now I clip dry paper to Gatorboard, or Fome-cor that has been covered

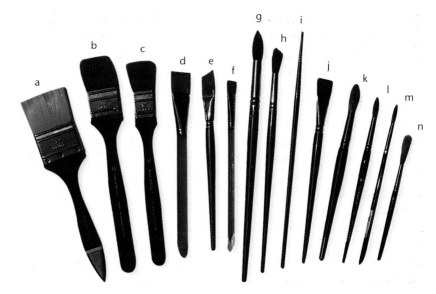

Brushes
From left to right, the brushes shown are: **a**: Robert Simmons 2-inch (51mm) Skyflow Wash 278W; **b**: Grumbacher Sable Essence 1½-inch (38mm) flat, no. 4424; **c**: Grumbacher Sable Essence 1-inch (25mm) flat, no. 4424; **d**: Holbein Series 500 1-inch (25mm) flat; **e**: Winsor & Newton Regency Gold ¾-inch (19mm) angled, no. 560; **f**: Maestro Gold ½-inch (12mm) flat, no. 500; **g**: Winsor & Newton Sceptre Gold no. 14 round, series 101; **h**: Winsor & Newton Sceptre Gold no. 12 round, series 101; **i**: Winsor & Newton Sceptre Gold no. 2 round, series 404; **j**: Winsor & Newton Sceptre Gold ¾-inch (19mm) flat, no. 606; **k**: Holbein Eldorado no. 18 round; **l**: Grumbacher Sable Essence no. 10 round, series 4420; **m**: Grumbacher Sable Essence no. 10 round, series 4425; **n**: Daniel Smith rigger, no. 2210.

with clear contact paper. To make your own board, cut two pieces of Fome-cor ½" (12 mm) larger than your paper size all around. Place one board over the other, so the edges are flush. (Using two boards makes it less likely to warp.) Then stretch clear contact paper carefully over the whole thing, smoothing out any wrinkles. With large boards you may have to piece the contact paper to fit. Be sure to cover all edges to make it waterproof. Now you have a strong, water-resistant board that washes off easily and is lightweight.

Brushes

There are many adequate brushes in a reasonable price range. You could get by with just a large and small version of either a flat or round brush. I use both rounds and flats that are either a mix of synthetic and sable or all synthetic. There are many available in art supply catalogs at discount prices. I use flats more than rounds and like several brands, especially Sceptre Gold, by Winsor & Newton; Holbein, Series 500; and Sable Essence rounds and flats by Grumbacher. Try both a flat and a round brush to see which feels best to you. Most people have a preference for one or the other. Handle the bristles carefully. Oils from your skin could make them repel pigment as you paint, and may age your brush.

How Important Are Brushes?

No matter what technique you use or invent, the type of brush you choose to paint with is a personal decision. Flat and round brushes make slightly different marks and vary in quality depending on the manufacturer. To find what works best for your painting style, try them out yourself.

I use whatever brush feels right at the time, whether flat or round, but not necessarily both in one painting. The brush marks below show how little difference there is between the marks of a flat brush vs. those of a round brush. In the mingles and color sketches on the facing page, there are no noticeable differences between the paintings made with round brushes and those done with flats.

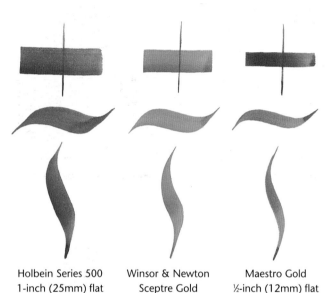

Holbein Series 500
1-inch (25mm) flat

Winsor & Newton
Sceptre Gold
¾-inch (19mm) flat

Maestro Gold
½-inch (12mm) flat

Choosing Your Brush

When working on the demonstrations in this book, use brushes that feel right for you for each task. Use rounds or flats. Use small brushes for small areas and large brushes to cover large areas quickly. Use the largest brush you feel comfortable with for each step.

I have listed the brushes I use for each demonstration, but this is only a guideline. Choose brushes that suit your needs.

Holbein Eldorado
no. 18 round

Winsor & Newton
Sceptre Gold
no. 12 round

Grumbacher Sable
Essence
no. 10 round

Daniel Smith rigger,
no. 2210

Mingled colors using a Maestro Gold ½-inch (12mm) flat.

Mingled colors using a Winsor & Newton Sceptre Gold no. 12 round.

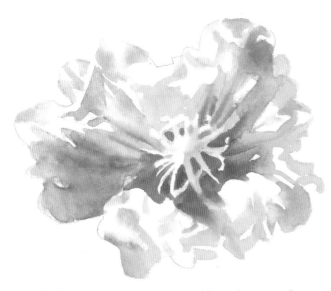

Hollyhock painted using a Maestro Gold ½-inch (12mm) flat.

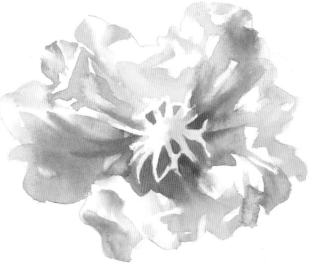

Hollyhock painted using a Winsor & Newton Sceptre Gold no. 12 round.

Paints

You don't need to purchase every color I list. My palette of colors is constantly evolving. I presently use pigments by Winsor & Newton, Pebeo, Daniel Smith and occasionally, Holbein and Grumbacher. There are many quality brands on the market. *The Wilcox Guide* (published by Artways) is a good reference for checking and comparing the qualities of each pigment made by each company. Be aware that not every pigment by every company is of lasting quality, nor do they all

brush out and flow onto paper smoothly. It is important to check the lightfastness rating of the paint you buy. You don't want your masterpieces to fade away. I had this happen after trying a substitute for the Brown Madder then on my palette. The customer who purchased the painting called to tell me it changed from rust to an orange hue. Luckily she still liked it! Needless to say, I tossed out the tube and learned my lesson.

Start with a warm and cool transparent version of each of the

three primaries (red, yellow and blue) and build slowly on that. Leave a few wells on your palette empty so there is room to try new colors, or keep a small spare palette for this purpose. Above all else, be sure to squeeze enough pigment into the wells: at least a half-tube or more! Keep paint moist by wetting often. This is more efficient if you flatten the pigment into the wells with a small palette knife. When you make a mound of pigment, the water runs down the sides and the top of the mound dries out.

Current Palette Colors (all Winsor & Newton except where noted)

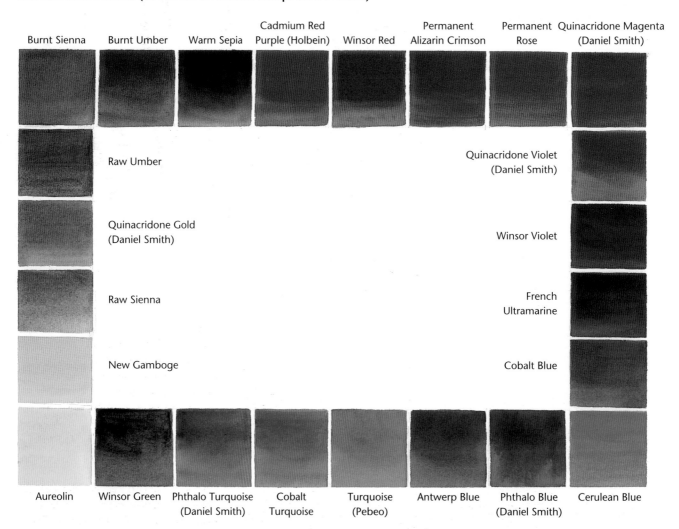

Burnt Sienna | Burnt Umber | Warm Sepia | Cadmium Red Purple (Holbein) | Winsor Red | Permanent Alizarin Crimson | Permanent Rose | Quinacridone Magenta (Daniel Smith)

Raw Umber

Quinacridone Violet (Daniel Smith)

Quinacridone Gold (Daniel Smith)

Winsor Violet

Raw Sienna

French Ultramarine

New Gamboge

Cobalt Blue

Aureolin | Winsor Green | Phthalo Turquoise (Daniel Smith) | Cobalt Turquoise | Turquoise (Pebeo) | Antwerp Blue | Phthalo Blue (Daniel Smith) | Cerulean Blue

Odds and Ends

I like to use two water containers, one for clean water to wet the paper or brushes and one for rinsing dirty brushes. A cellulose sponge next to them lets me wipe off excess water from brushes. I keep a spray bottle nearby for wetting my paints and the paper. (Use distilled water to avoid the growth of mold in the palette.) If you work often, the paints will stay moist. If you won't be painting for a few days, remember to occasionally uncover and wet the paints with a sprayer or dropper bottle. Always keep colors clean.

Blending and Scraping Tools

Blenders: (Zoltan Szabo Angled Bristle Brushes): **a:** 1½-inch (38mm) Old Style; **b:** 2-inch (51mm); **c:** 1½-inch (38mm) Richeson.

Scrubbers: d: Artsign no. 6 filbert, Imperial series 704, used oil brush; **e:** Artsign no. 4, Imperial series 703, used oil brush; **f:** Cheap Joe's no. 6 fritch scrubber; **g:** Morilla 500 no. 8.

Other: h: old clay modeling tool for scraping, **i:** old toothbrush, **j:** natural sponge.

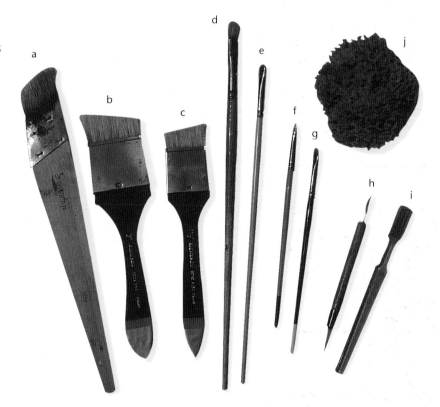

Palette

Choose a palette with a cover and deep enough wells to hold adequate paint (a half-tube or more) and plenty of mixing room. Arrange colors in an order that resembles the color wheel. It helps to have the warm and cool colors separated. You will become familiar with the location of each color by giving them permanent locations on the palette. You may find it useful to leave one or two wells empty for experimenting with new trial colors, or keep a small spare palette for this purpose. This is my Robert E. Wood palette.

Mixing Luminous Color

Because of its transparent nature, watercolor is the perfect medium for expressing the qualities of light. To achieve clean, luminous color mixes, you must become familiar with the characteristics of your colors. It is advantageous to play with each color, so you know its carrying power (impact and intensity), its transparency, its hue (the name of a color on the color wheel), and how it mixes with the other colors in the painting. Be reassured that there are no rules that can't be broken. However, it helps to understand the rules before you break them. By getting to know your colors firsthand, you aren't just taking someone else's word for what they can do. You will know what to expect.

Avoid Mud

After early years of mixing mud, no matter how I worked, I discovered that not all pigments give the same results. Through workshops I was introduced to the idea of using only transparent pigments and avoiding the opaque ones. I replaced Indian Red with Brown Madder (which I no longer use), Cadmium Yellow with New Gamboge, and Yellow Ochre with Raw Sienna. While some of the replacements are not perfectly transparent, they do create cleaner colors and, therefore, less mud.

Limit your palette, for a while, to several transparent varieties of the three primaries and mix browns, grays, greens, purples and oranges from these. You will learn a lot from doing this, and your paintings will be cleaner and brighter. Other ways to avoid mixing mud are to mix no more than three colors together and never more than one opaque in a mixture.

Pink Madder (Pebeo)

Permanent Rose

Quinacridone Magenta

Permanent Alizarin Crimson

Pinks mingled with
Aureolin and Cobalt Blue

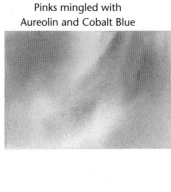

Color Mixing Exercise

Make graded washes of four different pink pigments. Next to each, mingle the pinks with Aureolin and Cobalt Blue, or your own choice of yellow and blue to see how the mixtures differ. Each pigment gives a different result. Compare the differences. The knowledge you gain from these exercises will make you a more confident painter.

Remember to clean your palette regularly, including colors and the mixing area. Gently wash them with an old brush and clean water, or if the whole palette is dirty, clean it under running water. Your paintings won't be any cleaner or more brilliant than your palette. Start each painting with clean, beautiful colors.

Primary Colors

The three primary colors (hues)—red, yellow and blue—are those that cannot be made by combining other hues. There are really no perfect primary tube colors. Each contains a bit of one or both of the other two primaries and is at least slightly warm or cool. For example, there are a number of blues available. Some, such as French Ultramarine, contain a little red, and are considered warm blues. Others, such as Cerulean Blue, contain some yellow, lean toward green, and are considered cool blues. Using both warm and cool versions allows you to mix a broad range of colors.

Warm and Cool Primaries From My Palette

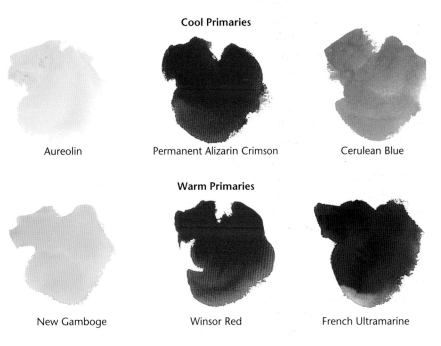

Cool Primaries

Aureolin Permanent Alizarin Crimson Cerulean Blue

Warm Primaries

New Gamboge Winsor Red French Ultramarine

Warm and Cool Blues From My Palette

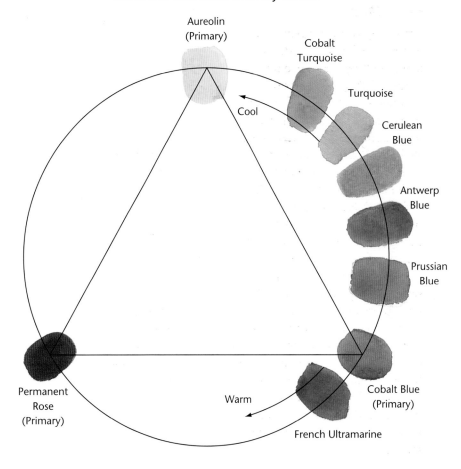

Aureolin (Primary)

Cobalt Turquoise

Turquoise

Cool

Cerulean Blue

Antwerp Blue

Prussian Blue

Cobalt Blue (Primary)

Permanent Rose (Primary)

Warm

French Ultramarine

Secondary Colors

If you combine two different primary hues, the result is a secondary color, such as purple, green or orange. Take care to choose two primaries that do not contain the complement of the desired color. (Complementary colors are the colors directly opposite each other on the color wheel. Combining a color and its complement will gray it, making a neutral, less intense color.) For the most intense secondary, use the two primaries closest on the color wheel to that secondary. For instance, if you wish to mix a clean green, choose two primaries that contain no red: Aureolin Yellow is a cool yellow with a bit of blue in it, but no red, and Phthalo Blue is a cool blue with a bit of yellow in it and no red.

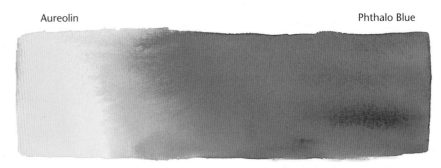

Aureolin Phthalo Blue

Create a Secondary Color
Make a clean green using a cool yellow and a cool blue.

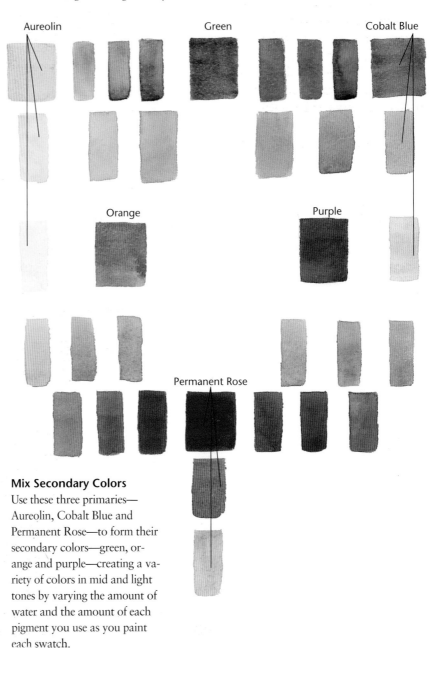

Aureolin Green Cobalt Blue

Orange Purple

Permanent Rose

Mix Secondary Colors
Use these three primaries—Aureolin, Cobalt Blue and Permanent Rose—to form their secondary colors—green, orange and purple—creating a variety of colors in mid and light tones by varying the amount of water and the amount of each pigment you use as you paint each swatch.

Complementary Colors

Be sure you understand the color wheel. The complement of a primary is the equal combination of the remaining two primaries. Knowing this comes in handy when you want to create vibrant passages of color. When placed side by side, two complementary colors really vibrate. When mixed in equal amounts, they tend to cancel each other out, forming a neutral gray. In unequal amounts, complementary colors make a wide variety of warm and cool grays. You don't need to invest in tubes of lifeless gray paint; the ones you can mix will be much lovelier. Remember that your grays will set off the clear pale or jewel colors and make them stand out.

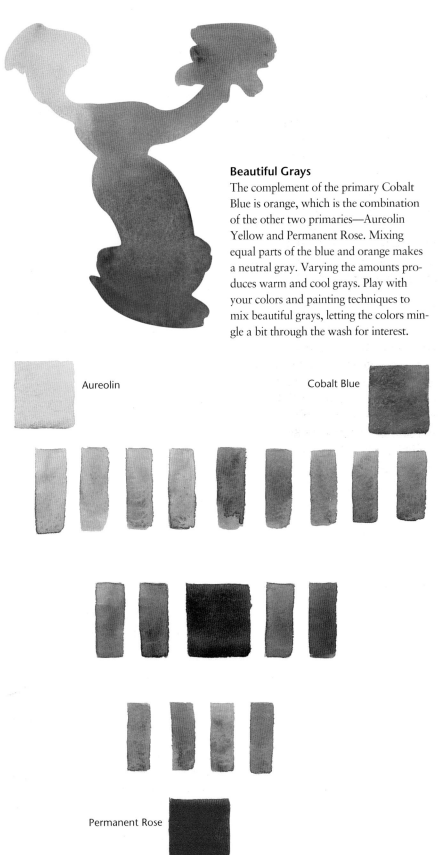

Beautiful Grays

The complement of the primary Cobalt Blue is orange, which is the combination of the other two primaries—Aureolin Yellow and Permanent Rose. Mixing equal parts of the blue and orange makes a neutral gray. Varying the amounts produces warm and cool grays. Play with your colors and painting techniques to mix beautiful grays, letting the colors mingle a bit through the wash for interest.

Aureolin

Cobalt Blue

Permanent Rose

Mix a Variety of Grays Using the Primaries
Make a variety of warm, cool and neutral grays using the three primaries.

Triads

Many workshops and books are based on using triads: nearly pure primaries that have similar characteristics of consistency, intensity, weight and look. They produce harmonious results when used together. There are three triad groups: nonstaining transparent, staining transparent and opaque. For our purpose of getting a feeling of light, we will be using the transparent pigments (both staining and nonstaining) for most projects.

Nonstaining Transparent Pigments
Uses: Clean washes; easy lifting; clear glazes.

Nonstaining colors can be easily lifted without staining the paper and have the clean look necessary for glazing. These are clear, delicate colors that give the feeling of atmosphere, airiness and light. They do not have great intensity or carrying power, and their range of values is light to middle, so they do not make effective darks. They are well suited to the subject of flowers. The nonstaining transparent pigments mix to make lovely, clean, luminous colors, including beautiful grays.

Staining Transparent Pigments
Uses: Rich darks; underpainting (stain the paper so they won't lift); clean, jewel-like color.

Staining colors have tremendous intensity, jewel-like color and will stain everything, including your palette. Some are too harsh to use alone, but mix beautifully, such as Winsor Green. They cannot be easily lifted, provide a full range of values and make lovely, deep, clean darks without any loss of transparency. They are very useful for painting strong value contrasts with dramatic results. When I found my work did not have enough carrying power (impact and intensity), I dared to add back some staining transparent colors (especially in the darks) and got plenty of punch! I had eliminated these because they were overpowering my washes and staining the paper where I wanted whites. These pigments are not terribly effective in pale, subtle washes because their intensity is reduced when diluted. While staining colors demand planning and an understanding of their traits, they will bring drama to your work.

Opaque Pigments
Uses: Cover well; create beautiful granulations when mixed.

Opaque pigments tend to be dense, heavy and chalky, such as Cerulean Blue and the Cadmium colors. They cover well and can be used almost full strength to hide the paper, but are unsuitable for glazing. They do not lift easily because of their density. They can produce mud if overmixed or if too many opaque hues are used together. For best results, try to achieve the color you want with the first wash, then leave it alone. In certain combinations their granulating quality is quite handsome (some of the pigment particles settle out into the valleys of the paper, creating a texture). They also make attractive mixtures with some of the staining pigments. Avoid mixing more than one opaque in any mixture for a clean result. Too many opaques at once can be a problem.

The subject of color is too vast to devote more space to here, so take the time to explore it by reading and experimenting. There are many good books about color on the market, and I suggest that you refer to them for further information.

Excellent Books on Color

Mastering Color and Design in Watercolor, Christopher Schink, Watson-Guptill

Making Color Sing, Jeanne Dobie, Watson-Guptill

Color Choices, Stephen Quiller, Watson-Guptill

Watercolor...Let's Think About It!, Judi Betts, Aquarelle Press

The Wilcox Guide to the Best Watercolor Paints, Michael Wilcox, Artways

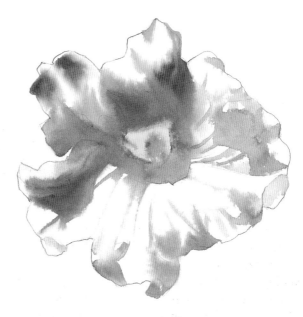

Nonstaining Transparent Triad
Three primary colors that make up this triad are Permanent Rose, Aureolin and Cobalt Blue.

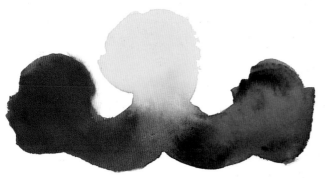

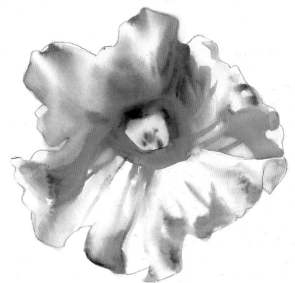

Staining Transparent Triad
Three primary colors that make up this triad are Permanent Alizarin Crimson, Winsor Yellow and Winsor Blue.

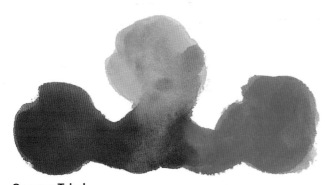

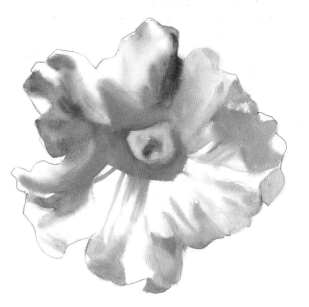

Opaque Triad
Three primary colors that make up this triad are Cadmium Red, Cadmium Yellow and Cerulean Blue.

Painting Methods

Direct Painting

Direct painting is achieved by putting juicy paint on a wet brush and applying it to dry paper. It can have a fresh look and be applied in any value from light to dark. The size and type of brush determines the amount of paint and water you can apply. Try to get it right with the first wash. Put the color down, soften any edges with clear water and a brush, and leave it alone!

Wet-in-Wet Painting

Wet-in-wet painting is accomplished by applying paint with a wet brush to wet paper, making the paint run and move. There are several ways to achieve a similar result.

The traditional method is to saturate the paper in a tub of cool water. Sponge off the excess water after about ten to fifteen minutes of soaking. Then staple, tape or clip the paper to a board that won't warp, or apply the wet paper to a board and squeeze out excess water with a rolled up towel. Suction will hold the paper down for a time. Work quickly with this method and be aware that it is often hard to control the wetness and the paints' movements.

I prefer a more controlled method. Use a paper that resists buckling (such as Waterford), and clip the four corners to a board while dry. Then wet an area with a clean wet brush, choosing one large enough to cover the area quickly. With another brush apply paint.

Paint only as much as you can easily handle as one passage. Look for convenient stopping places to end the wash, such as where an element touches the edge of the paper, or where two elements meet. If that is not possible, just soften the edge with a clean wet brush. After it has dried you can carefully re-wet it, add paint from there on and the two areas will blend together. You can always wet the leading edge of your wet stroke as you move to another area, so that they blend together. At first you may get a few drips, but you'll get control the more you work. This method takes advantage of the fluidity of the medium and still allows a hard edge if you want it.

Direct painting will dry with hard edges unless you soften them.

Wet-in-wet painting creates soft, flowing edges.

Dry-Brush

Dry-brush consists of dragging a brush loaded with more paint than water over dry paper. This produces a textured result as the brush skips over the surface of the paper. The greater the texture of the paper, the greater the resulting texture will be. I hardly ever use this technique. It is more useful in landscape painting.

Glazing

Glazing involves the application of thin layers of transparent color, one layer over another. Each layer must be absolutely dry before the next one is applied, or you might disturb or lift the existing paint. Glazing gives the effect of looking through pieces of stained glass and can be very beautiful. The white of the paper glows through the transparent layers, producing luminous color. It is important to work on a paper that won't let the paint lift too easily. Experiment with different papers to see which ones you prefer.

I do glaze to some extent, but whenever possible, I prefer to get the color mixture and intensity right on the first application. You lose some luminosity every time you touch the paper in the same place. Learn to compensate for the fact that the paint dries lighter than it looks when wet. Apply it a little more richly than you think it should be. You must be brave to do this, but it's worth trying. You can't paint timidly and expect dramatic results!

Create texture with the dry-brush technique.

Permanent Rose is glazed with a transparent layer of Cobalt Blue.

Mingling Colors

It is important to vary colors as you charge paint into the wet areas while painting with the wet-in-wet or direct method. This technique gives the washes variety. Each time you go back for more paint, vary the color, keeping it changing often from warm to cool. For instance, you might charge more than one blue into an area of blue. Then you might add some pink or yellow and so on. The wet paper will make the paint mix, and the tilt of the paper encourages the paint to move, forming gradations. As you go along you can judge how much paint to add with each stroke. The mixture will be cleaner and richer if it mixes on the paper rather than on the palette. You control the mixtures by regulating the amount of water you put on the brush, by how wet the paper is and by how much pigment you charge into the wet areas.

Method of Mingling Colors

When mingling, work with a limited palette of two to five colors for clarity. Choose transparent pigments rather than opaque. Wet the paper in stages as you paint, and don't try to paint too large an area at once. This will put you in control.

A round or flat brush of at least medium size, capable of holding a generous load of paint, works best with this technique. Always choose the biggest brush that can do the job. It will let you work faster and show fewer strokes. Be sure to wet the paints in your palette or put out fresh pigment.

Pick up paint with a wet, but not dripping, brush (touch it to a sponge or paper towel to remove excess moisture). You may make a puddle of that color on the mixing area of the palette. When well loaded, touch the brush to the wet paper and stroke it on. Then dip into another color, perhaps of different temperature (you don't always need to wash out the brush when picking up a new color), and paint that in next to and touching the edge of the first color. If there is too much water and not enough pigment on the brush, a bloom will form, pushing the first color away, instead of mixing with it. The two colors should fuse together softly.

Continue in this manner, changing the color often. If you are using only two colors, keep switching back and forth. Be sure to pick up enough pigment. Make it darker than you think it should be; it will dry lighter. Tilt your paper to aid the mingling process. You can also pick it up and move it in different directions to make the paint move. You will have a bead of paint at the bottom of the painted passage. To prevent a bloom from occurring, touch the bottom edge of the bead with a thirsty (just damp) brush to remove the excess, or carefully touch it with a tissue or paper towel. Let the paint dry before judging the results. Do many trial washes of mingled color to get a feeling for how much water and pigment to use.

Mingled Colors From My Palette
This is the full range of mingled colors from my palette from yellows and reds to blues. Notice the variety of mixtures possible.
Try this with colors from your palette.

Permanent Rose, New Gamboge,
Antwerp Blue

Quinacridone Magenta, Winsor Violet,
Cobalt Turquoise

Turquoise, Quinacridone Magenta,
Aureolin

Antwerp Blue, New Gamboge,
Permanent Rose

French Ultramarine, Permanent Rose,
Burnt Sienna

Winsor Green, Winsor Violet,
Quinacridone Magenta

Examples of Mingled Colors

It is a helpful exercise to mingle many combinations of colors from your palette.
You might want to keep a sketchbook dedicated just to color exercises. Label
everything. It makes a handy reference when you are deciding what colors to use
together in a painting.

Mingle Colors: Hollyhock Bud

Paint one hollyhock bud with controlled, wet-in-wet areas using mingled colors (mixing greens), then paint another with flat, glazed washes using tube greens. Compare the results of each. Chances are the mingled version has more life and movement.

1 Complete Drawing
Keep it simple. Draw just the pencil guidelines.

MATERIALS LIST

Paper
Waterford 140-lb. (300gsm) cold-pressed

Palette
Permanent Rose
Antwerp Blue
Permanent Alizarin Crimson
New Gamboge
Sap Green
Hooker's Green Dark
Aureolin

Brushes
Flats
½-inch (12mm)—use to apply paint
¾-inch (19mm)—use to wet areas
(or use the brushes of your choice)

2 Paint the Large Petals
Begin wetting the paper with a large brush from the top of the upper petal down to the top of the lower petal and into the base of the flower. Use a smaller brush to mingle Permanent Rose and Antwerp Blue with small amounts of Permanent Alizarin Crimson and New Gamboge. At the leading wet edge, soften it with a wet brush to avoid a hard edge, except at the top of the lower petal. Wet the lower petal and mingle the same colors through it. Again, wet the edge adjoining the flower base. Then wet that area out into the stem. Mingle greens with a small brush using New Gamboge, Antwerp Blue and a touch of Permanent Alizarin Crimson.

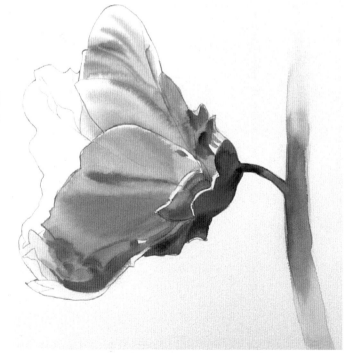

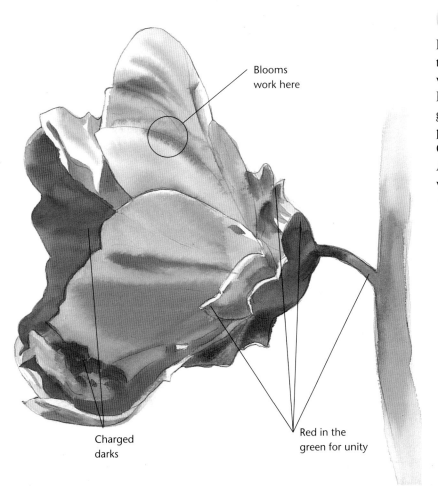

Blooms
work here

Charged
darks

Red in the
green for unity

3 Paint the Dark Center Petals

First mingle the light values at the top of the petal using a small brush with Permanent Rose and Antwerp Blue. Leave a hard edge at the beginning of the lower section. Then paint that with Permanent Alizarin Crimson, Permanent Rose and Antwerp Blue, mingling them onto wet paper.

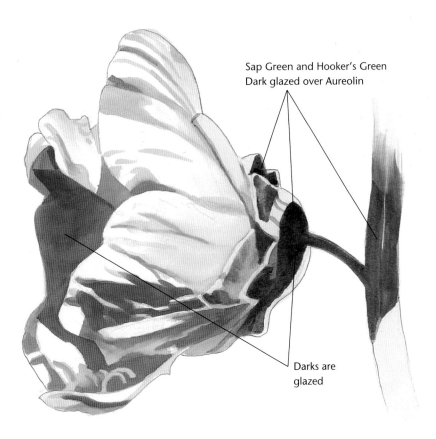

Sap Green and Hooker's Green
Dark glazed over Aureolin

Darks are
glazed

Glazed Hollyhock Bud

Paint this bud using traditional glazing methods and premixed greens made from Permanent Rose, Permanent Alizarin Crimson, Sap Green, Hooker's Green Dark and Aureolin.

The finished result appears flat and boring even though glazed. The paint is applied in flat washes with little variety. The darks are built up by glazing. There are too many hard edges and the whole effect is unexciting.

Vary Edges

When painting, your edges should vary in texture, size, shape, color and value for interest and variety. They are an important means of expression and will help you communicate the mood of the subject.

Hard Edges

When you lay down wet paint on dry paper and allow it to dry, it forms a hard edge. Hard edges draw attention to an area, but too many hard edges can be jarring and stop the viewer's eye from moving through the painting. This element is especially important when painting close-focus flowers. A common mistake is to paint a large, light flower shape with all hard edges formed by a dark background. It looks harsh and unnatural.

Soft Edges

Softening some edges as you work creates transitions from one area to another. You can also soften edges after the painting is dry. This can be helpful, but doing so while the passage is wet is preferable.

To soften, put down a wash and while it is still wet, touch the area you want softened with a fairly large flat or angled wet brush. The additional moisture draws the painted mixture in a wicking motion and dilutes the color, forming a bleed. If too much water is on the brush, you may get a bloom or crawl-back. If it is only damp, it will not produce a softened edge, but will pick up color instead. It takes a bit of practice to get the feeling of how wet to make the brush.

All hard edges.

One edge softened; paint its edge with a large, wet brush.

All soft edges.

To get hard edges, paint one wash of paint on dry paper and let it dry. Then paint a second wash of equal value adjacent to the first.

To get softened edges, paint one wash of paint on dry paper. Immediately paint a second wash adjacent to it. The edge where they touch will bleed and soften.

Lost and Found Edges

A variety of lost and found edges (hard and soft) are pleasing and encourage the viewer's eye to move through the painting. Watercolor is well suited to forming a wide variety of edges. Take advantage of this to explore many ways of expressing your own style with beautiful edges. If you use calligraphy, avoid outlining all the shapes; instead, employ it creatively within the design, perhaps in or near the center of a flower. Different degrees of wetness produce a great variety of edges for you. Experiment with how many you can produce.

Create lost and found edges.

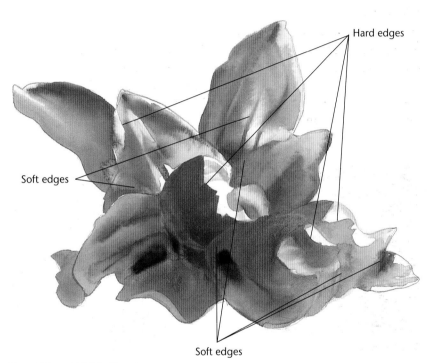

Hard edges

Soft edges

Soft edges

Vary Edges Within Petals

Choose a limited palette and a few simple shapes. Wet the petals in stages and charge colors onto the wet paper, letting them bleed together and mix. These dahlia petals were painted with Permanent Rose, Permanent Alizarin Crimson, Antwerp Blue and New Gamboge. Let some edges dry to become hard. Soften others.

Paint a shape on dry paper, then soften some edges.

Texture

You can produce a variety of effects in watercolor. The type of paper you use changes the results, as do the pigments and amount of water. For our subject you need not be too concerned with creating textures. Most textures will be somewhat subtle and can be applied with your usual painting tools. Do not let texture become too important. It can easily overwhelm the painting. Use it only to add variety and strengthen your painting. Vary the amounts of paint and water to get different effects.

Spray

Spraying applies small drops of water or paint over the paper. Depending on the type of sprayer, the drops can be small and fine or large and runny. Choose your sprayer carefully. Always make tests on scrap paper first to avoid a disaster. A pump spray bottle, trigger spray bottle or any empty sprayers around the house will work.

Spatter

Spatter makes a broad pattern of spray. The drops of liquid are farther apart when they drop onto the paper. Try this on wet and dry surfaces. Use more water for more spray. With a toothbrush or a brush loaded with either water or paint, flick the bristles with your finger, or tap the handle against your hand or against another brush handle. This helps control the direction in which the spatter falls.

Phthalo Blue on cold-pressed paper is sprayed with clear water from a bottle.

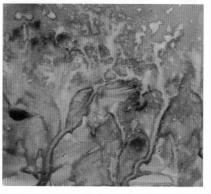 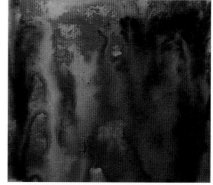

Darks on 500 Series high plate bristol board are sprayed with water for more texture.

One color spattered over another while wet.

Blooms

Blooms occur when a wet liquid touches a damp area. Apply paint or water into, or next to, a slightly damp passage. The fluid will flow into the damp area, forming an uneven edge as it picks up paint and moves it away before drying. We've all experienced this often unwanted effect. Sometimes it can be surprisingly welcome. Play with making some blooms to learn what to expect if you add fresh paint to an almost dry area.

Drops

With a small dropper or dropper-topped bottle (Oiler Boilers from Cheap Joe's), drop water or paint into a damp or wet area. You can also drop mixed paint from a brush (a round works best). Many variables can change your results: paper surface, paper's degree of wetness, amount of paint and water in the mixture, humidity of the air, height from which dropped and angle of the paper.

Chemical Reactions

You will find that some pigments mix and spread differently than others. This could be caused by their source, wetting agent or binder.

Practice mixing your colors in a variety of combinations so you can predict how they will react when mingled in a painting.

Color is charged into damp paint to create a bloom.

Color is dropped into damp paint for interesting textures.

Winsor Violet and Aureolin chemically react to form texture on cold-pressed paper.

Winsor Green and Quinacridone Magenta chemically react to form texture on cold-pressed paper.

Lifting Techniques

You can use lifting for some degree of correction. Use it to soften or define shapes, or to lighten, sometimes almost back to white. It also can create texture. There are several methods and tools for lifting: brushes (soft or stiff) or the end of the handle; knife blade, razor blade, or any sharp object; sponges; and erasers. Use your imagination for other tools you may find around the house. It is always best to first try removal techniques that will least damage the paper surface. If these don't work, take more aggressive measures.

Soft papers do not hold up to harsh treatment. Papers with ample sizing allow easier lifting. Papers with little sizing absorb the paint and do not give it up. Staining pigments do not lift out completely. Of course, if you take the time to plan carefully, you may avoid having to lift at all. It can ruin your painting if not done with care. Always test the method first on scrap paper, so you will know what to expect.

Wet- or Damp-Lift

To lift from a wet or damp area, touch the area with a soft brush, trying to loosen the pigment from the paper, and blot gently with a tissue. When painting wet-in-wet, lift with a damp brush or sponge for a soft-edged result. With the end of a brush handle, knife, credit card or other hard-edged tool, press and squeeze the paint off the paper while it's just damp, not wet (timing is important). You must be bold with your stroke for it to be effective. Don't make a tiny line or it will just fill back in with paint.

Dry-Lift

Dry-lifting is usually done for corrections or improvements. Start lifting first with a soft, damp brush. If that doesn't work, try a scrubber with stiff bristles or a toothbrush used in a circular motion. Blot with a tissue or paper towel. For small lifts with a hard edge, cut a stencil out of a sheet of acetate or stiff paper, and sponge or scrub (with a bristle brush or a toothbrush). Then blot with a tissue. A hard eraser or even an electric eraser works on dry paper. Be very careful not to do damage. Knives and razor blades scrape tiny even lines and edges nicely. Don't get carried away with them! Use sandpaper for a large area, knowing it will damage the surface somewhat. You can re-wet an area and use the previous wet-lift techniques. You may also submerge the paper in a tub and lift with a brush, sponge or rag while underwater, or hose it with a sprayer. Keep in mind that soft papers won't hold up to these vigorous methods and any paper can become damaged. Scrubbed areas usually take repainting differently and may appear dark.

A wet brush lifts out texture from damp Phthalo Blue.

This color was squeezed out with the end of a brush while the color was still damp.

Drylift color with a razor blade after the paint is dry.

Create a Pattern With Flower and Bud Shapes

The entire shapes of flowers, stems and leaves is not a major concern when painting with a close perspective. The aim here is to take a creative look at flowers, not to create a botanical rendering, as in photo realism. Don't report every minute detail you see, but be creative and design with shapes. Instead of painting everything in focus, keep some areas diffused and out of focus for variety.

You need to understand the general forms to be able to express them confidently. The turn of a petal, thrust of a leaf, delicacy of a bud and strength of a stem are all important considerations. You will be dealing with flowers whose overall shapes are circular, conical or bell-like and clusters or combinations of these. Up close, they are much more abstract, and it is easier to be creative with the shapes. In most cases the outer shape will not be as important as the patterns of shapes throughout the subject. Because you are simplifying the design, you must hone your skills of shape making. The fewer shapes you make, the more skillfully you must handle them.

Link shapes to form simple patterns and always edit. Avoid too many small petal shapes by squinting to see the larger patterns of lights and darks. Light plays a big role in how shapes appear and what kinds of shadows are formed. Train your eye to see the patterns of light and dark and how they define the shapes. This will form the backbone of your painting.

Plan the values—lights, middle values and darks—for strong design and be sure to save enough lights. There may be one very large shadow over the center and much of the flower. If so, paint it that way and ignore the details you know are there under the shadow. You don't have to paint them! Instead, play with a beautiful color passage as a statement of the shadow.

Bud Shapes

Buds come in many shapes and sizes and are often interesting enough to be the subject of a painting by themselves. Study them and try to develop a painting around just one bud. It's a great exercise in simplifying.

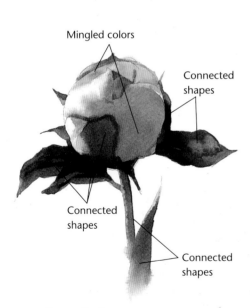

Mingled colors

Connected shapes

Connected shapes

Connected shapes

Peony Bud

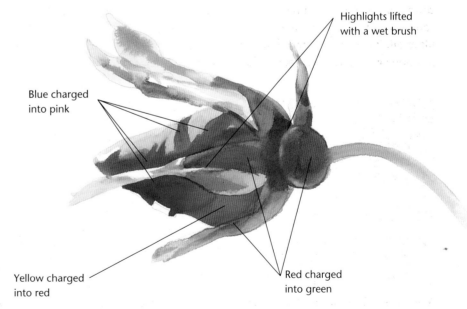

Highlights lifted with a wet brush

Blue charged into pink

Yellow charged into red

Red charged into green

Rose Bud

The Character of Petal Shapes

Circular-Shaped Flowers

Many flowers are round, like my favorite, the peony. The petal shapes are more important than the outer shape though. There are a variety of shapes within a peony flower. They can be large, small, curved, or have angles and curled edges. They give you endless variety to design with. Connecting, or linking, shapes is critical in designing these flowers with interesting patterns. The petals of most flowers are translucent and will let light shine through them if the light is strong enough or if the petal is not shielded from the light. This can be used to advantage in designing the light patterns. Look for ways to improve your design with these qualities.

Conical-Shaped Flowers

Cone-shaped flowers such as gloxinia, amaryllis and lilies have fewer petals to design with, but offer beautiful colors and shapes. This is an opportunity to design with fewer shapes and really simplify. You might use only three to five petals in your design.

Cluster of Flowers

When the flower is made up of a cluster of small flowers, such as delphinium or hydrangea, you have a chance to design by linking the smaller flowers together to make larger shapes. Use the patterns formed by the lights and darks to assist your design choices. You might also link some petal shapes with background shapes for interest.

Combined Flower Forms

Flowers such as gladiola and iris are made up of more than one circular form. The petals are few, but quite large, and their frilly edges are interesting. The patterns of light and shadow are very important to designing with these shapes. Be sure to edit your subject, linking and overlapping patterns of shapes, values and light. The buds are good design elements, from the tightly wrapped young ones to those beginning to unfold. Perhaps you could combine one or two with a flower form for a creative design.

Partially Opened Dahlia

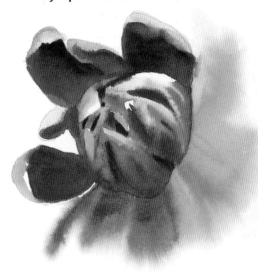

Peony

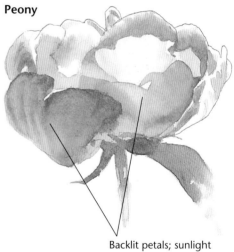

Backlit petals; sunlight shines through

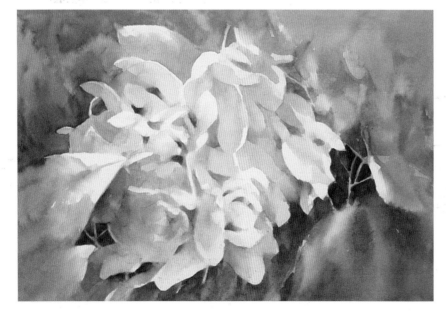

Clustered flowers give you an opportunity to combine shapes.

HYDRANGEA
Waterford 140-lb. cold-pressed paper
10" × 12" (25cm × 30cm)

Flower Clusters: Backlit Phlox

Painting a flower made up of a cluster of smaller flower shapes is an opportunity to hone your simplification skills. Use the lighting to help see patterns of linked forms that create larger shapes. You may choose to paint some detail in just enough small flower shapes or parts to make the painting readable. The rest can mingle and blend. Avoid perfection. Instead, seek to make a creative statement with your art.

MATERIALS LIST

Paper
Waterford 140-lb. (300gsm) cold-pressed

Palette
Permanent Rose
Permanent Alizarin Crimson
Antwerp Blue
New Gamboge
Raw Umber

Brushes
Flats
 ½-inch (12mm)—use to apply paint
 ¾-inch (19mm)—use to wet areas
(or use the brushes of your choice)

1 Simple Drawing
Connect the shadow shapes.

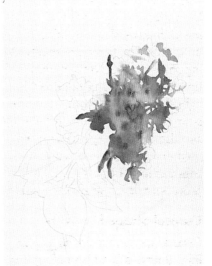

2 Paint Large Shadow Shapes
Wet the area with a large brush and then use a smaller brush to charge with Permanent Rose, Permanent Alizarin Crimson and Antwerp Blue, from the top down. Let them mix and run together. Drop in New Gamboge to indicate a few centers of the tiny flowers. Don't get carried away with too many dots!

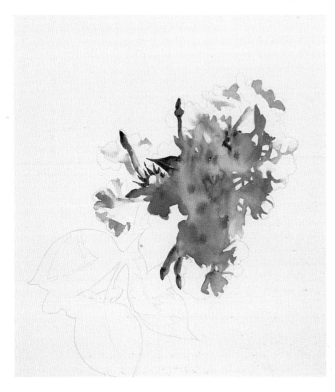

3 Add Leaves and Buds
At the upper left, connect a few leaves and buds to the flower shape by softening their shared edges with a small brush. Use Raw Umber and Antwerp Blue. The outer pale petal shadows will be lighter toward the edges of the flower mass.

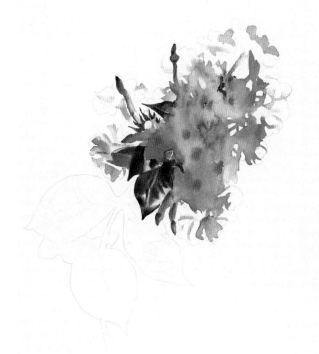

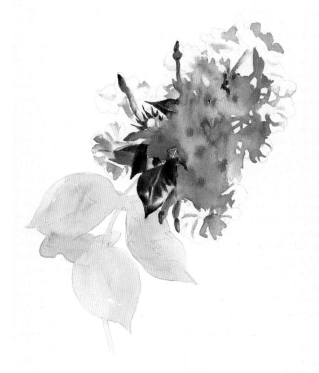

4 **Leaves Below the Flower**
These are away from the light and are quite dark. A few spots have sun shining through them. Keep these light. Wet the whole shape and add New Gamboge with a small brush. Drop in rich amounts of Antwerp Blue, Raw Umber and a touch of Permanent Alizarin Crimson. Also add the light petal shadows at the bottom of the flower.

5 **Lower Leaves and Stem**
Wet the whole leaf section and paint loosely with New Gamboge using a small brush.

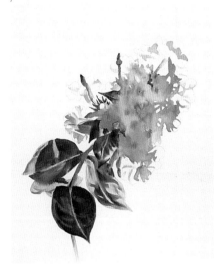

6 Paint Darks

While the New Gamboge of the lower leaves is still wet, drop in Antwerp Blue, Raw Umber and Permanent Alizarin Crimson with a small brush, letting them mingle. Where you want hard edges, wait to paint the area until the color is dry. Soften edges where needed, such as at the lower end of the stem.

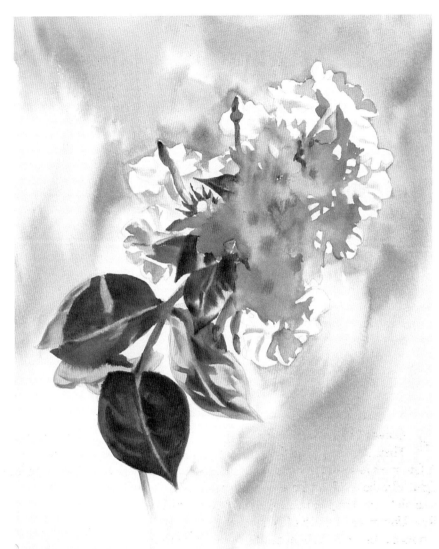

7 Background

Begin at the top and wet the paper with a large brush, working around the flower shape carefully. Quickly add Raw Umber, Antwerp Blue and Permanent Rose and let them mingle. Re-wet the paper at the wet leading edge if it begins to dry. Keep it wet in advance of laying in the paint, so the colors will mingle. Soften the bottom edge to diffuse it to white paper for a vignette effect.

Flower Centers

The centers of many flowers offer wonderful shapes and could be the whole subject of the painting. There are many different types of centers. Coupled with the shapes created by light, flower centers are great to start with if you want a simple subject.

The centers of hollyhocks and rhododendrons have been the subject of many paintings for me. Other interesting choices are magnolia, peony, dahlia, amaryllis, epiphyllum (Easter cactus) and night blooming cereus. If the center has long, thin stamens, like the rhododendron, you can paint around them or mask them before painting. I prefer painting around them because it allows for softening of edges and a more natural character.

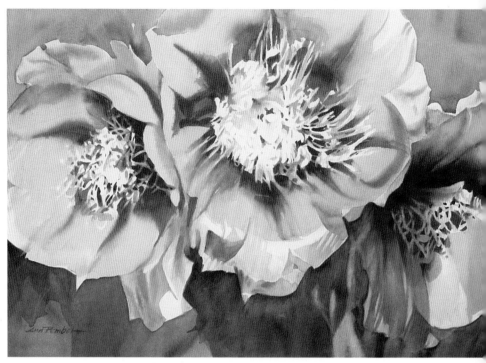

I saved the light center shapes of these flowers by painting around them.

PRICKLY PEAR CACTUS
Arches 140-lb. cold-pressed paper
14½" × 21½" (37cm × 55cm)

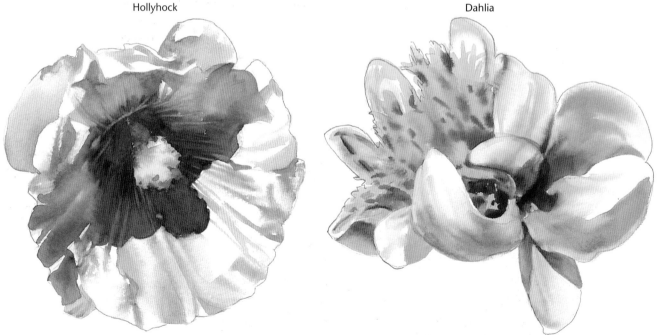

Hollyhock

Dahlia

Centers and Petals
Always soften some of the center edges to avoid a bull's-eye appearance. Connect shapes and mingle color. Don't overdo the details. Simplify any large inner shadows by connecting them and mingling color. This will help define the center.

Painting Flower Centers: Rhododendrons

It is helpful to practice painting many different kinds of flowers and centers. Graceful rhododendron stamens provide a wonderful design opportunity. You will get to practice painting around shapes, mingling colors and softening edges.

1 Complete the Drawing
Complete your drawing of a rhododendron blossom. Keep the center and petal shapes simple and connected.

MATERIALS LIST

Paper
Waterford 140-lb. (300gsm) cold-pressed

Palette
Permanent Rose
Antwerp Blue
Quinacridone Magenta
New Gamboge

Brushes
Flats
½-inch (12mm)—use to apply paint
¾-inch (19mm)—use to wet areas
(or use the brushes of your choice)

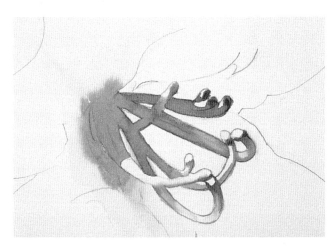

2 Paint the Stamen Shapes
Wet the stamen shapes all at once and float in Permanent Rose, Antwerp Blue, Quinacridone Magenta and New Gamboge with a small brush, letting them mingle as one shape. Save the whites and soften the center to the left of the stamens to blend them into the flower.

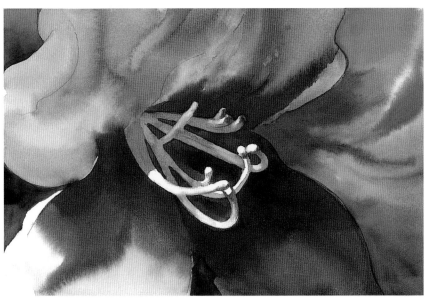

3 Paint the Petals
When stamens are dry, paint around them with darks. Use a large brush to wet the area first, then charge in Permanent Rose, Antwerp Blue, Quinacridone Magenta and New Gamboge.

Consider the Background

A painting is often handled very strongly except for the background. Using a close viewpoint can improve this aspect of the painting. It becomes more important to integrate the background with the subject because you are editing so closely. If you close in on a flower enough to eliminate foliage, then the petals become the background.

Value

The value of the background helps develop the mood of the painting. It can be dark in value for a high-contrast effect, or a middle or light tone to blend with parts of the flower (which is necessary for a high-key effect). If you decide to aim for high contrast, don't make the mistake of painting hard edges all around the flower shape. This produces a jarring cookie-cutter look. Instead, let the edges weave in and out by keeping some of them softened, by blending into the flower, by using a value close to the flower, or by using a similar color. You might alternate light areas against dark and dark areas against light for variety.

Flat Wash
A wash of Phthalo Turquoise and Quinacridone Magenta equally mixed is uninteresting and flat.

When Phthalo Turquoise and Quinacridone Magenta are mingled on wet paper they are alive and colorful.

Winsor Violet, Winsor Red and New Gamboge mingled on wet paper.

Winsor Green and Quinacridone Magenta mingled on wet paper.

Phthalo Blue and Permanent Rose mingled on wet paper.

Phthalo Blue, Quinacridone Gold and New Gamboge mingled on wet paper.

Color

Staining transparent pigments make it possible to achieve very dark backgrounds and retain clean color. Forget black and Payne's Gray and the mud made with opaque colors mixed together. Instead, practice mingling combinations of the Winsor (Phthalo) colors or other staining pigments. Try mixing them with some nonstaining pigments and some opaques. If combining them with an opaque pigment, use only one opaque to avoid making mud. When choosing background colors, try repeating a touch of the warm colors from the flowers in the background and leaves. It is usually found reflected somewhere in the foliage and will help weave the painting together, giving it unity. Backgrounds made with equally mixed colors can be flat and unexciting. Be sure to use unequal amounts and let them mingle.

Foliage

The supporting parts of the plant can play a supporting role in your painting. You may only hint at or include parts of the leaves or stem, but these parts can help make the flower shapes stand out. Or you can combine parts of foliage with some petals to form a pattern of light or dark shapes. Become familiar with the forms, even though you may not be painting the whole plant.

Observe the types of edges the leaves have: smooth, jagged, saw-toothed, regular, irregular. Are they large or small, clustered, widely or closely spaced? Do they have pronounced veins? Are they translucent, flat or bumpy? Avoid too much detail, which can draw attention from the subject. If you include a defined leaf or two, be careful to integrate the patterns with the flower.

Stems can be thick, thin, straight, curving, winding, diagonal, smooth, rough or prickly. Avoid stems that are straight with no interruption. This can look awkward and draw attention from the subject. Instead, weave the stem in and out of leaf forms, or petals when possible, to create interest.

Keep Backgrounds Simple
Backgrounds are a support for the subject. They should be kept simple. Mingled color is often all that is necessary. Color variety gives a painting liveliness. Flat colors mixed in equal amounts can be boring and lifeless.

PANSIES
Waterford 140-lb. cold-pressed paper
10" × 14" (25cm × 36cm)

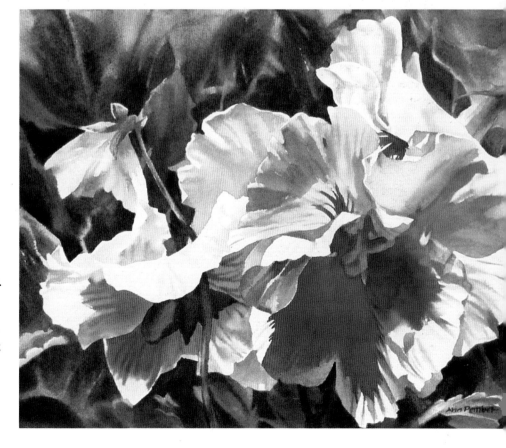

Background Foliage Patterns

Practice painting some abstract leaf shapes. Most of your backgrounds will be fairly abstract if you choose a close viewpoint. Just suggest a few leaves, without a lot of detail. Instead play with color, shapes and pattern.

Wet sections and mingle colors, varying the edges. Save some lights and add pink to the green in some areas. This could be reflected from flowers and gives life to the greens. The greens can mingle from blue-green to yellow-green and rust-green. Make the colors and shapes used interesting. Do several of these for practice.

MATERIALS LIST

Paper
Waterford 140-lb. (300gsm) cold-pressed

Palette
New Gamboge
Quinacridone Gold
Permanent Rose
Antwerp Blue
Winsor Green

Brushes
Flats
 ¾-inch (19mm)—use to apply paint
 1-inch (25mm)—use to wet areas
(or use the brushes of your choice)

1 Drawing and First Washes
Make pencil guidelines to block in the major shapes. Wet the paper at the upper left with a large brush. Then use a smaller brush to mingle New Gamboge, Quinacridone Gold, Permanent Rose, Antwerp Blue and Winsor Green. Use the yellow and pink colors to indicate lights, and the blues and greens and their mixtures to indicate darks. Soften some edges with a wet brush. Let the upper leaf shape flow into the one below. Connect shadows for one shape. Apply darks as the wash is just damp.

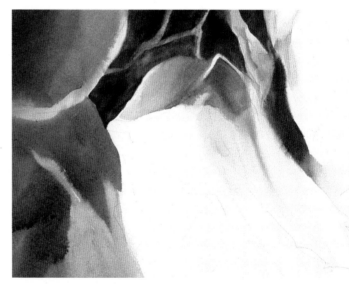

2 Add Some Darks Early On
Using the same palette as in step 1, paint the darks at the top. Paint around the positive light leaf shapes and stems, then paint the light leaves. Blend the lower wet edge to nothing.

3 Work Down Through the Middle
Re-wet the leading edge of the previous wash so the two areas will blend together, then continue working in darks.

4 Complete the Right Side
Use the same mingling technique and colors, and a variety of edges to complete this background foliage.

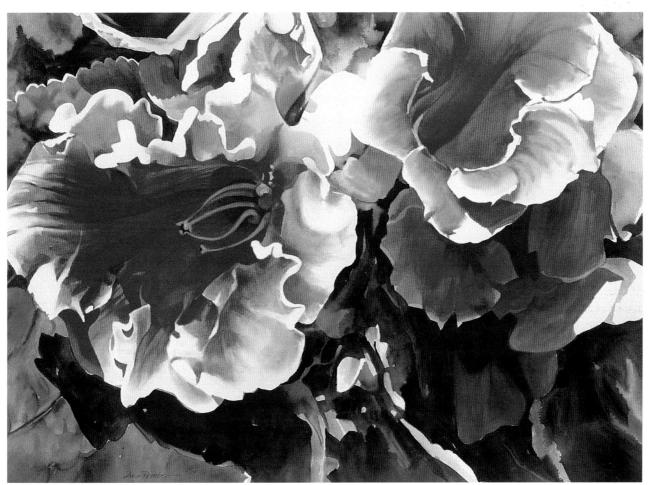

Suggest Foliage in the Background
Make the background undefined, with just enough form to give the suggestion of foliage.

GORGEOUS GLOXINIA
Arches 300-lb. (640gsm) cold-pressed paper
21½" × 29½" (55cm × 75cm)
Collection of Nell Shehee

Integrate Background Foliage With the Flower: Hydrangea

When painting a flower with a close point of view, merge the background with the flower shapes in some places to make them relate to one another. Do this by mingling a wash through both areas or by painting each with a similar value or color.

MATERIALS LIST

Paper
Waterford 140-lb. (300gsm) cold-pressed

Palette
Permanent Rose
Quinacridone Magenta
Quinacridone Gold
Winsor Green

Brushes
Flats
 ¼-inch (6mm)—use for small areas
 ½-inch (12mm)—use for mid-size areas
 ¾-inch (19mm)—use to wet areas and to paint large areas
(or use the brushes of your choice)

Reference photo for hydrangea.

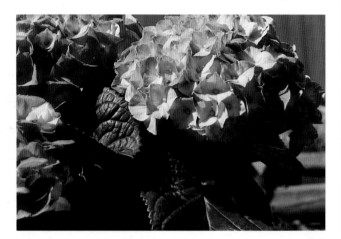

1 **Complete the Drawing**
Keep the drawing simple and fairly light.

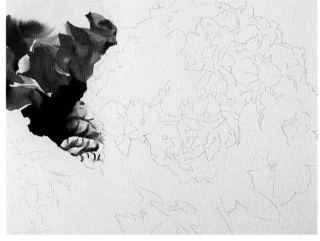

2 **Paint the Upper Left**
Mingle Permanent Rose, Quinacridone Magenta and a touch of Quinacridone Gold and Winsor Green in the upper left with a mid-size brush. Save a few whites by painting around them, and keep a few edges defined, but most quite soft. Be sure to use enough paint, especially when you paint the deep green leaf. Where the leaf and flowers above touch, the paint should be wet enough to flow between the two areas, merging them. Hint at some detail in the leaf and a few flower centers without going too far. Soften edges within the detail area so it doesn't become too harsh.

3 Add the Flower Shadow and Lower Foliage Darks

In the same manner as step 2, paint the shadow of the flower at the right, using your large brush for wetting, and your mid-size brush for applying paint. Before it dries, continue painting through to the shadowed leaf area under the flower. In the flower shadow use Quinacridone Magenta, Permanent Rose, Quinacridone Gold and a touch of Winsor Green. As you move into the leaf shapes, increase the amount of Winsor Green and Quinacridone Gold. This needs to be very dark, but not opaque. You want drama, but also clarity. Float some touches of the pinks into the greens for unity.

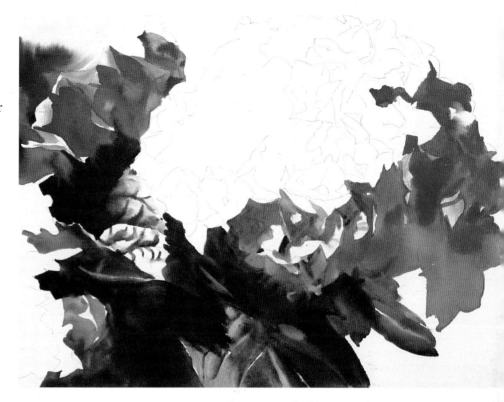

4 Paint the Light Side of the Flower

Finally, paint the lighter petals using the same palette and your small and mid-size brushes. Mix some green into the flower for unity. Save some whites and vary the edges from hard to soft. Link several petals together for better design, keeping some areas out of focus. Paint the background using a large brush with minglings of Quinacridone Magenta, Quinacridone Gold and a touch of Winsor Green. Soften an edge occasionally and make the value close to that of the flower in places. If necessary, glaze an area that needs to be deeper. Clean up any ragged edges.

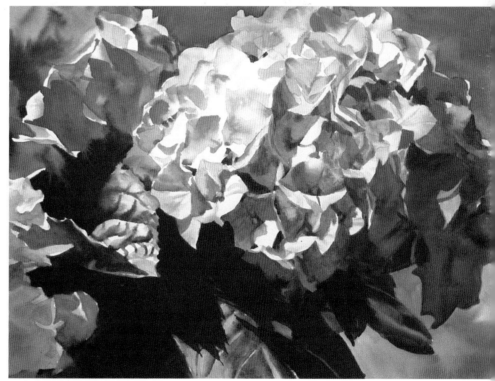

HALLOWED HYDRANGEA
Waterford 140-lb. (300gsm)
cold-pressed paper
10½" × 14½" (27cm × 37cm)

Consider the Lighting

The distribution of light and shade in a painting is influenced by what the artist sees. She determines what and how to represent the forms, interpreting what happens to them when illuminated by the glorious light. Without light there would be nothing. It literally gives us and everything in the world life, and allows us to see forms. As artists we can make use of natural light or use artificial means of lighting our subject. Some artists create elaborate setups inside using a variety of lighting equipment. I do not choose to work that way, so I will concentrate my comments on the use of natural lighting.

Avoid getting too caught up in using a particular way of lighting your subject. The important issue is to hone your observation skills and look for patterns and shapes that are pleasing to you. There is no need to get too clinical about this. Learn to trust your feelings about how you respond to what you see and how you think you should convey those feelings. Spending time contriving the lighting does not guarantee successful results. Instead learn to work with nature; become a keen observer.

Capturing the Light

Many wonderful lighting possibilities exist outdoors. You can take advantage of them by working with nature and a good camera. While I agree that working from life is the best way to paint, it is not always expedient. Flowers are in constant flux, opening, reaching toward the light, blowing in the breeze. The most wonderful light patterns can be very fleeting. Unless you have perfect recall, which I lack, a camera shot or a sketch is the only way to record what you want to paint. Use the camera like a sketchbook to record many different arrangements of your subject under a variety of light conditions. Learn to edit, edit, edit; first with the camera, then with paint. Do some quick sketches on the spot to record the emotional response you have at the moment. You might even make some notes: color suggestions or other pertinent remarks.

Types of Light

As you work with the light, observe the different effects created under as many conditions as possible—early morning light, high noon, late afternoon, dusk, haze, fog—as long as there is enough light to form shadows. The direction and intensity of the light establish the key, or main tonality, of a composition. If you want to create drama, look for the shapes with high contrast, long shadows, backlighting or brilliantly lit areas. To create a high-key feeling, search for an overall flooding of light, with many shapes bathed in light. For something in between, emphasize midtones.

Light defines and reveals the images we seek to paint.

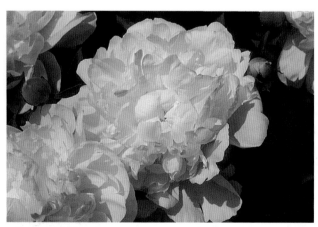
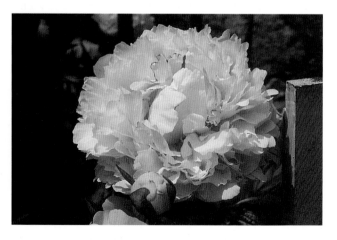

Floodlighting
Two peony flowers with floodlighting.

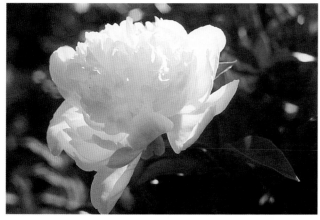
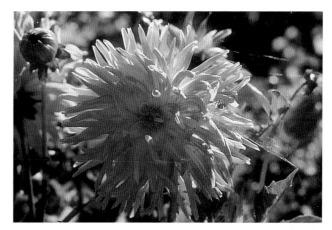

Backlighting
Two examples of backlighting: peony (left) and dahlia (right).

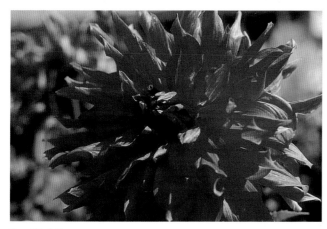

Spotlighting
Two examples of a spotlight effect: dahlia (left) and hollyhock (right).

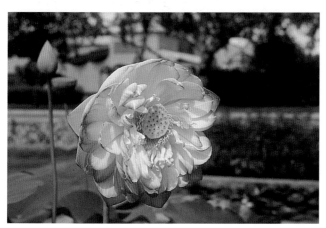
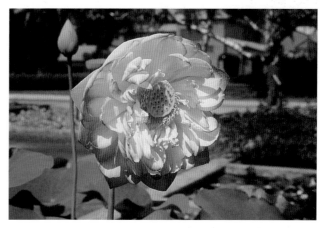

Floodlighting vs. Spotlighting
Observe the differences between the lotus flooded with light (left), and the same lotus under spotlighting (right). Note the subtle color changes and high key of the floodlit flower. The shadows are fairly light. The spotlit flower has deeper shadows and more drama. Colors are also richer. It is easier to see the patterns of connected shadow and light shapes.

Designing Your Composition

A good composition is essential to good painting. It requires planning and some training in looking at shapes. A painting transforms the three-dimensional world into a two-dimensional one, which is in itself a form of abstraction. We edit what we observe all the time. No two people see in exactly the same way. When we paint, we use our personal symbols for our subject. These symbols can have the simplicity of a child or be very complex. Above all, we are expressing the effects of light on our subject. Light defines and reveals everything we see.

Shape of the Paper

Consider the shape of the paper when planning your design. Design shapes with relation to the page. Consider the negative shapes they create, making them equally pleasing and giving them variety. Plan for dominance of line, color, value, shape, size, direction or texture to establish unity. Even consider your signature an element. It can detract from the design if it is too large, badly placed or slanted across a corner. Think before you make a mark, and don't add any that are unnecessary. Try to plan for an interesting pattern and pleasing movement that will lead you through the painting. A close point of view can feel more personal and less formal than the traditional point of view.

The Three Basic Values

Dark value

Middle value

Light value

Each Pigment Has a Value

Winsor Violet
(dark value)

Cerulean Blue
(middle value)

Aureolin
(light value)

Some pigments produce deep color. Others are not capable of more than a middle or light value at full strength.

Aids for Composing Design

To help see values, look through a piece of medium blue, red or green plastic or glass. I prefer blue; it takes away the local color and gives the illusion of seeing the world in grays. You can purchase a product called Val-u Viewer (advertised by Murphy Enterprises in the art magazines), or cut two small mats and sandwich a piece of colored plastic mylar between them for the same effect (bottom right).

My ultimate tool is a pair of blue glasses a student made for me using stained glass and a coat hanger for the wire frame and handle (bottom right). It works very well. You can order blue glasses from Creative Health International, (800) 819-9098 (top right). Ask for Color Therapy Eyewear. They come in seven colors. I prefer Indigo.

See Shapes and Values as Patterns

It helped me to learn to see several small, adjacent shapes of similar color or value as one large, simple shape. Look at a flower. Now, squint your eyes or look through a piece of colored glass or a Val-u Viewer (see page 54) to eliminate the details and see the big picture. Think of the whole flower as a shape instead of individual little petals.

Think of the flower in terms of its areas of lights, medium tones and shadows, or darks. These are the three main values you will deal with. Then think of all the lights as one simple shape, the middle tones as one shape and the darks as one shape. By linking several areas of the same value, you simplify, creating patterns that make stronger paintings.

White has the greatest visual strength and will always draw the viewer's eye. Design the whites carefully, relating them well to each other. The intervals between them should vary. Light-struck petals may contain numerous pale to light middle values. These may be seen as one large, light value shape encompassing many petals.

The middle values are especially important in pulling the design together and make up a good portion of most paintings (50 percent or more). They make the lights stand out. Be sure to make the middle values dark enough.

Consider whether the value contrast should be subtle or strong. If strong, make the darks deep enough and don't make them opaque. Avoid isolating lights by surrounding them with darks having all hard edges. Soften some edges and integrate the darks with the subject.

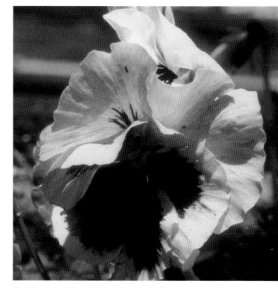

Reference photo shows range of values.

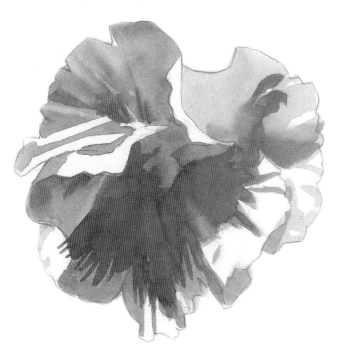

Light and light-middle values.

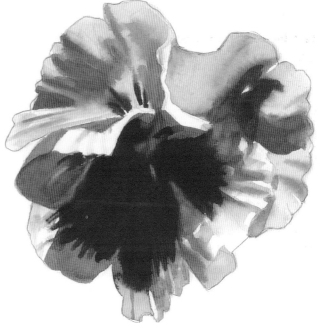

Darks have been added for a full range of values.

Create a Center of Interest

The center of interest, or focal point, is whatever area the viewer's eye is drawn to first. As you develop a design, place your center of interest carefully. Long ago, methods of placement were developed, such as the "Rule of Thirds." If you divide the paper into thirds in each direction, the four intersections of the lines are considered pleasing areas for the center of interest. Avoid placement in the center, or far into a corner. These are awkward and impede visual movement through the painting. Have just one major center of interest. Remember that the lightest light, placed next to the darkest dark, draws the eye and naturally becomes the center of interest. There can be secondary areas of interest, but they should not be too distracting.

Other Elements Of Design
- Unity—Repetition of value, color, shape, line, number, direction, size or texture will unify the painting.
- Variety—Vary the value, color, shape, line, number, direction, size and texture to prevent monotony.
- Movement—Horizontal, vertical, diagonal or curvilinear. Diagonal designs can be especially dynamic. Creating a pleasing rhythm helps lead the viewer's eye through the painting.

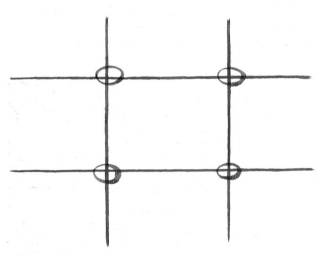

The Rule of Thirds
Divide the paper equally in thirds in each direction. The areas of intersecting lines have long been considered pleasing areas for placement of the focal point.

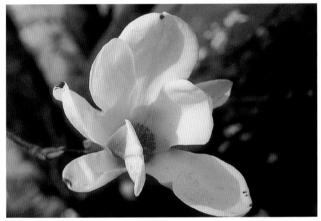

Compare the four designs (opposite) created from this magnolia reference photo.

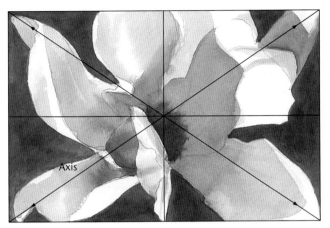

Poor Design

The petals reach out like an axis, pointing to each corner. The focal point (center of the flower and vertical petal next to it) is too centered. It divides the painting into two equal parts.

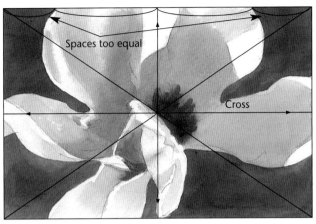

Poor Design

The petals almost form a cross shape which is rather static. The side petals divide the painting in half. The center and middle petal are too centered, dividing the painting in half. The top petal shapes are too similar, and the focal point too centered.

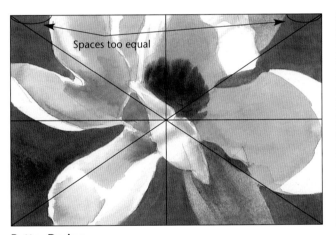

Better Design

The side petals are improved, but the top petals could be more varied. The center and middle petal are better placed a bit higher, but are still centered from left to right.

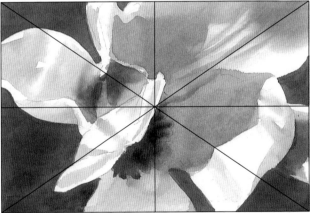

Best Design

This design has better movement, almost a pinwheel effect. There is a better variety in shapes and sizes of petals. The center and adjacent petal (focal point) are better placed, though near the center.

See and Paint Simple Shapes: Begonia

Darks and lights give a painting liveliness. Link their shapes when possible to avoid a jumpy look. Do this by softening edges, or using similar color or texture. Here, try your hand at seeing and painting shapes using a limited palette and distinct values.

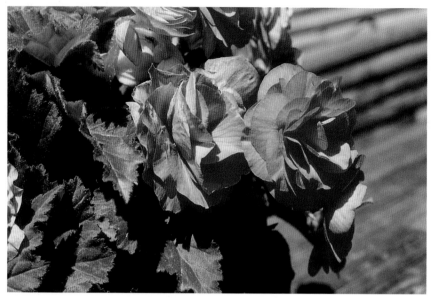

Reference photo for begonia.

MATERIALS LIST

Paper
Waterford 140-lb. (300gsm) cold-pressed

Paints
Permanent Rose
New Gamboge
Permanent Alizarin Crimson

Brushes
Round
 no. 10—use to wet areas and
 apply paint
(or use the brushes of your choice)

1 **Complete the Drawing**
Simplify a begonia blossom into three shapes by connecting the areas of similar value.

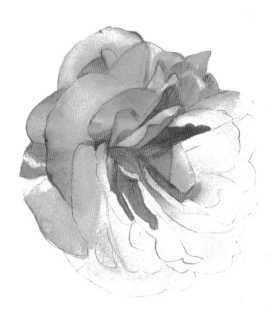

2 Lay in Light and Midvalues

Use all the colors on the palette to mingle a light value wash, including some midtones. Soften some edges. Add the center darks.

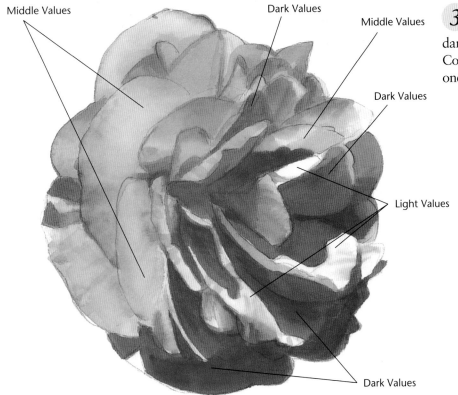

Middle Values

Dark Values

Middle Values

Dark Values

Light Values

Dark Values

3 Add Dark Values

Complete by painting in the darks using the same colors. Connect the shapes and paint as one. Paint around the lights.

Value Sketch: Rose

Plan your composition before your final drawing by painting several small sketches using Sepia or black watercolor to work out the value patterns and areas of mass. Think about what kind of statement you want to make. Then, draw the subject lightly in pencil. In this example I've chosen to paint a rose. Combine shapes and values to create simple patterns. Good shapes are the foundation of your painting. Describe shapes with care and give them variety.

MATERIALS LIST

Paper
Strathmore Imperial 140-lb. (300gsm) cold-pressed

Palette
Warm Sepia (Sepia or Black will work as well)

Brushes
Flats
 ¼-inch (6mm)—use for small areas
 ½-inch (12mm)—use for small areas
 ¾-inch (19mm)—use for large areas
Round
 no. 6—use for mid-size areas
(or use the brushes of your choice)

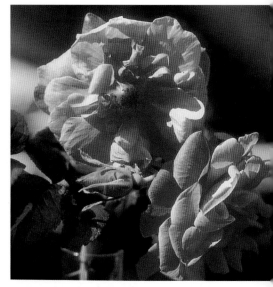

Photo reference for rose.

1 **Complete the Drawing**
Complete a simple drawing of a rose.

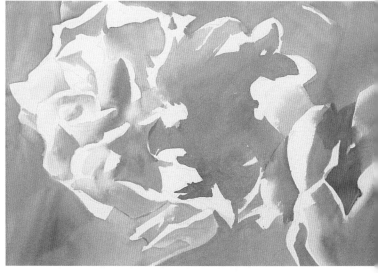

2 **Middle Values**
Begin by painting in the midtones of the upper petals, leaving the white of the paper as your lights. Wet each area with a large brush before floating on paint with a mid-size brush. Connect the areas by wetting edges and softening them with a clean wet brush. Move down through the center of the flower and into the lower petals. Don't concentrate on what petal you're working on, but rather, think about the value shapes, and combine several.

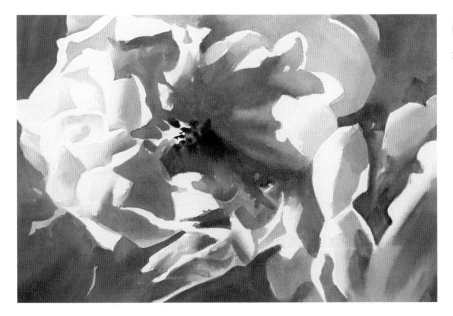

3 Dark Values
As the paint begins to lose moisture, carefully charge in darks.

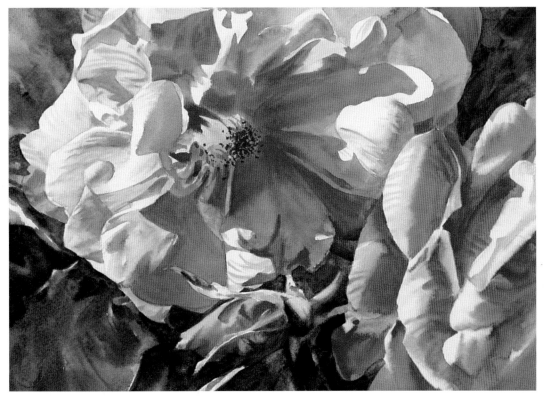

Full-Color Painting: Rose
Achieving balanced values and colors of the right intensity is important to making a painting work.

GLOWING ROSE
Strathmore Imperial 140-lb. (300gsm)
cold-pressed paper
11" × 14" (28cm × 36cm)

Try a Limited Palette

Beautiful paintings can be achieved with only one to three colors. If you have trouble with color mixing, try simplifying the process by painting with just one warm and one cool color. You might also explore painting with *analogous*, *complementary* or *monochromatic* color schemes (see the Glossary, page 121 for more information on these terms).

Focus your attention on the elements of good design and other aspects of painting by simplifying your color choices, and your paintings will have a unity and harmony of color.

Aureolin and Winsor Violet

Burnt Sienna and French Ultramarine

Permanent Rose and Phthalo Turquoise

Quinacridone Magenta and Winsor Green

Quinacridone Gold and Phthalo Blue

Permanent Alizarin Crimson and Turquoise

Make Minglings with a Limited Palette
Try making a variety of minglings using only a warm and a cool pigment.

Paint in Two Colors: Pink Phlox

Develop a painting using only one warm and one cool color. Mix the colors in as many different combinations as you like, in a variety of values. See how inventive you can be and have fun exploring the possibilities. This is a great way to test the full range of your colors. Remember to mingle colors, work with value patterns, create edge variety and employ the elements of good design.

MATERIALS LIST

Paper
Waterford 140-lb. (300gsm)
 cold-pressed

Palette
Permanent Rose
Phthalo Turquoise

Brushes
Rounds
 no. 12—use for small areas
 no. 18—use for large areas
(or use the brushes of your choice)

Permanent Rose Mixed to deep purple Phthalo Turquoise

Paint with a limited palette of two colors: a warm and a cool.

1 Drawing
Complete a simple drawing of phlox.

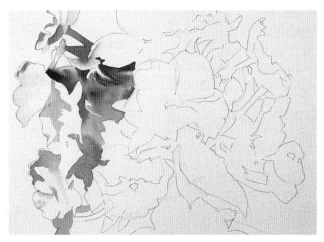

2 Begin Mingling
Start painting with both colors right away using your smaller brush and mingling one section at a time on wet paper. Include a few darks right away. Vary the colors and values.

3 Link Shapes

Use your smaller brush to connect the sections by softening mutual edges to blend them. Continue including darks to balance the values as you work. You should not need to come back to add them. The main dark is the foliage under the center flower; use a deep mix of pigment, tending toward the turquoise. Avoid getting caught up in too much detail there. Paint the dark leaf and stem shapes together as one shape with your larger brush.

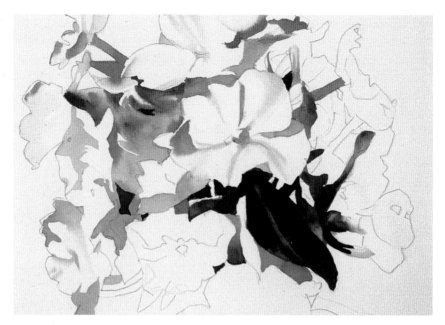

4 Paint the Shadow Side

Add more shadow darks, using less water with your paints, creating a deeper value on the petals to the right side. Paint them as one general shape, adding definition with additional color and your smaller brush just before the wash dries.

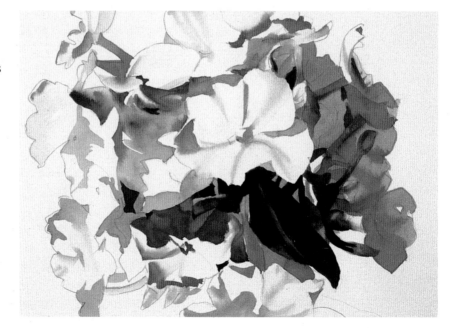

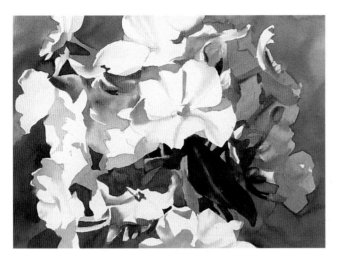

5 Paint the Background

Paint in the background with the larger brush, mingling the shades of blues, purples and pinks. Make it dark enough to give contrast to your flower, painting carefully around the light shapes.

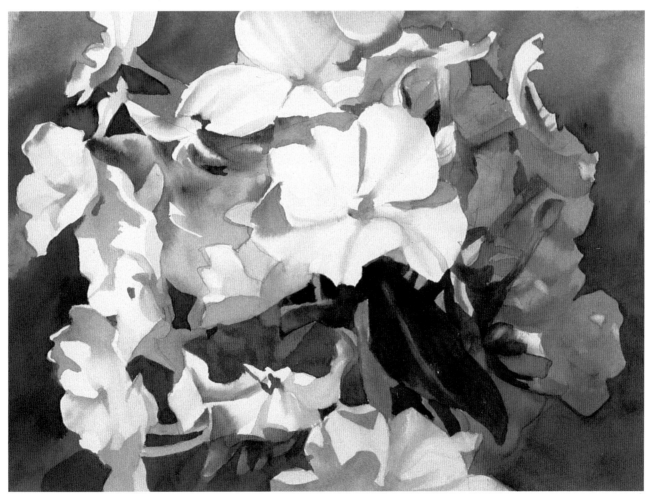

6 Final Touches

Add definition to the petals where needed and darken the background with additional layers of color to get a strong dark value.

PINK PHLOX
Waterford 140-lb. (300gsm)
cold-pressed paper
7½" × 11" (19cm × 28cm)

Tone the Paper Before Painting

Toning the paper with a pale wash of transparent color before painting gives your work a lovely glow and gives immediate unity to the whole painting. Try this using several different colors to see which color effect you prefer. You might choose a light value wash of either Permanent Rose, Aureolin, New Gamboge, Cobalt Blue, Antwerp Blue or other transparent colors. Using the yellows or pinks gives your work a sunny glow. Cool colors, such as blues or greens, make the painting feel calm and serene. If you expect to do some lifting, use a staining color to avoid lifting back to white.

Toning Method

If doing a drawing first, make the drawing just dark enough to show through the light tone you will paint. You may add the drawing after toning the paper, once the paint is thoroughly dry.

Clip your paper to a board to prevent buckling, wet the entire sheet with water using a large brush. Mix a generous puddle of paint with a large brush and apply a stroke across the top of the sheet with the board angled up. Paint each consecutive stroke just touching, not overlapping, the previous stroke (or you will get a striped effect). At the bottom, blot the bead to prevent a bloom or crawl-back.

Let the wash dry thoroughly before starting a painting. Paint over the underpainting in the usual manner, being careful not to disturb the underpainting. If you like this effect, prepare several sheets at once for convenience.

Warm, pink-toned paper (Permanent Rose).

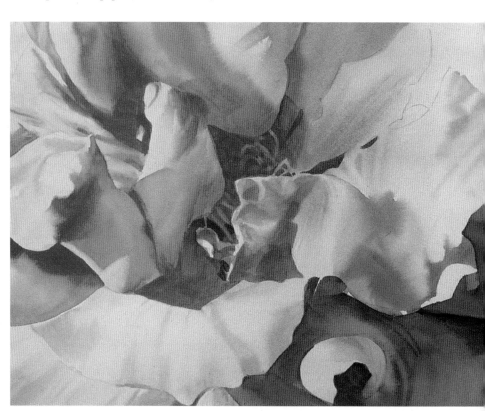

Watch your painting take on a warm glow as you paint over the warm tone.

RADIANT ROSE
Waterford 140-lb. (300gsm)
cold-pressed paper
10" × 15" (25cm × 38cm)

Cool, blue-toned paper (Cobalt Blue).

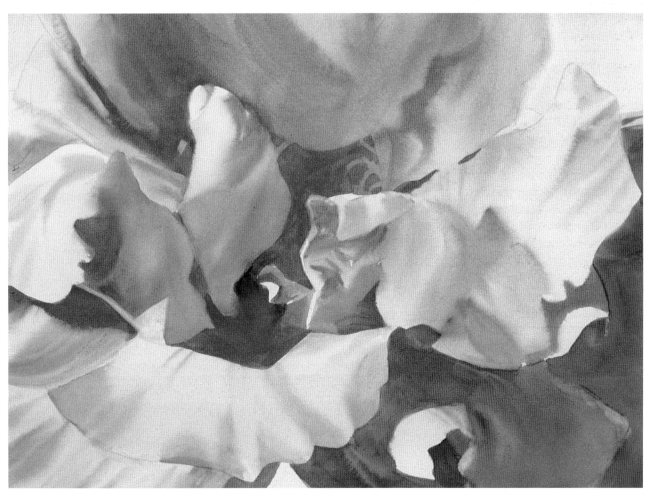

Watch your painting take on a cool tranquility as you paint over the cool tone.

ROBUST ROSE
Waterford 140-lb. (300gsm)
cold-pressed paper
10" × 15" (25cm × 38cm)

Try Painting on a Smooth Surface

You might enjoy working on smooth surfaces for unusual textures and effects. I especially like the way paint moves on Strathmore 500 Series high plate five-ply bristol board. This slick surface requires a whole different technique of painting, more like oil painting, using a dabbing motion to apply paint.

Paint sits on the surface instead of being absorbed, dries with full intensity, allows considerable lifting and correcting when either dry or wet, and produces many textures by spraying water or paint into wet washes. Working on a tilted board will aid paint movement.

This surface accepts paint better with more than one application, so you can build up layers of transparent paint. Brushstrokes feel slippery, and may streak with the first or subsequent layers unless carefully floated on. The first layer of paint can be lifted by wiping while either wet or dry, but later layers must dry before being lifted, or the paper fibers will pill and raise.

I first began using bristol board for landscapes of streams and rocks, finding the textural possibilities extraordinary. (See pages 110-119 for a demonstration of painting on a smooth surface.)

Create Interesting Effects

Practice painting on bristol board using different amounts of water and paint.

Cobalt Blue applied to a dry surface

Cobalt Blue applied to a wet surface

Cobalt Blue and Quinacridone Magenta mingled on a wet surface

Cobalt Blue and Quinacridone Magenta sprayed with water using a toothbrush while the paint was wet

Lift Easily

Repeated lifting is possible on bristol board. Practice lifting paint while wet and while dry using a clean, wet brush, paper towel or tissue.

Lifting while wet
(Quinacridone Gold and Phthalo Blue)

Lifting when dry
(Quinacridone Gold and Phthalo Blue)

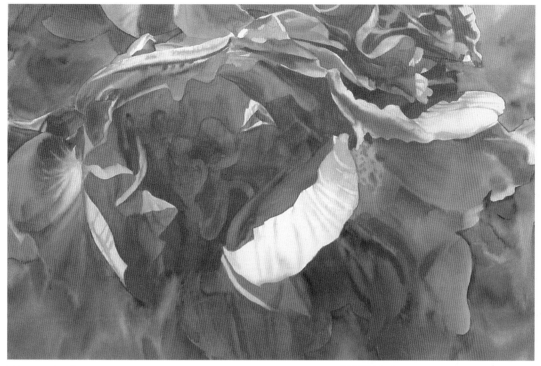

Watercolor Paper

The Waterford watercolor paper is painted here with a direct mingling technique. It has softened edges and only a small amount of glazing to deepen a few darks.

BOUNTIFUL BEGONIA
Waterford 140-lb. (300gsm)
cold-pressed paper
14½" × 21½" (37cm × 55cm)

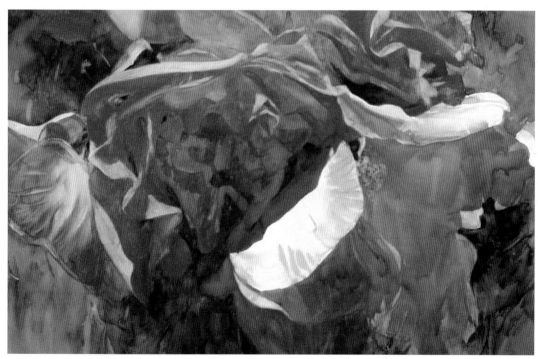

Bristol Board

For the bristol board, I applied the paint to wet and dry paper in sections. The difference is that the color sits on top of the surface and, therefore, dries more richly. Several areas received lifts and repainting with no loss of freshness.

BLITHE BEGONIA
Bristol board
14½" × 21½" (37cm × 55cm)

Practice Loosening Up: Rhododendrons

S ometimes it's hard to loosen up and we wind up with tightly rendered paintings. I discovered that I could make myself paint more loosely with this exercise. If you have a problem with making tight paintings, give this a try.

MATERIALS LIST

Paper
Arches 140-lb. (300gsm) cold-pressed

Palette
Rose Madder Genuine
Antwerp Blue
New Gamboge
Permanent Alizarin Crimson

Brushes
Flats
 ½-inch (12mm)—use for small areas
 ¾-inch (19mm)—use for mid-size
 areas
 1-inch (25mm)—use for large areas
Blender
 1½-inch (38mm) angled or flat—use
 to wet areas or paint large areas
(or use the brushes of your choice)

1 Drawing
Complete a detailed drawing.

Not enough color change in background

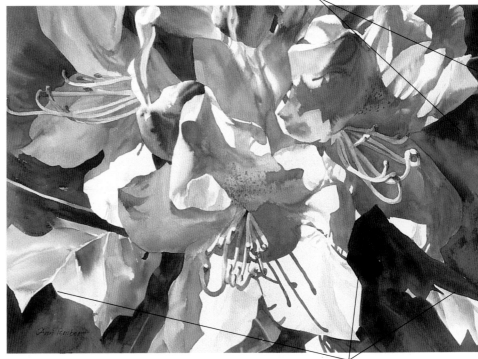

Edges too hard here

2 Paint the Flowers
With your usual brushes, mingle the colors and soften some edges. Add the amount of detail you normally include. Paint the foliage around the flowers, linking some shapes. Make the shadows fairly dark. In the center of the flower paint around the stamens. Then carefully paint them in. The large shadow around them should be linked to the small shadows made by the stamens. Glaze any areas that need extra color. Work as long as you like!

RHODODENDRON RHAPSODY
Arches 140-lb. (300gsm) cold-pressed paper
14½" × 21½" (37cm × 55cm)
Collection of Melinda and Alexander McAra

3 Make a Second Painting

This time, transfer very simple drawing guidelines—just enough to place the major shapes. Work for no more than one hour, painting very quickly. The thinking process was worked out in the first painting, so just have fun here. Mingle bold washes on pre-wet paper, painting in sections with large and mid-size brushes. Keep the detail on the flower centers. The background should be soft and out of focus. If you feel it needs more after an hour, fight the desire to keep painting. You might even finish before the hour is up!

RHODODENDRON RADIANCE
Arches 140-lb. (300gsm) cold-pressed paper
14½" × 21½" (37cm × 55cm)

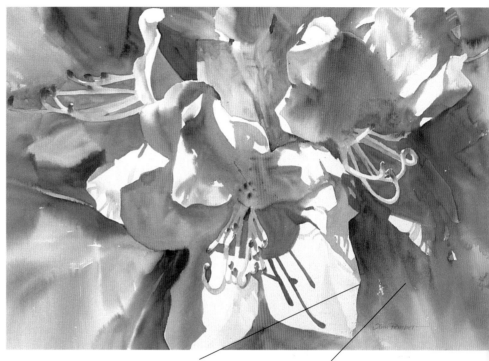

This edge is still too hard.

Background color mingle is improved. It has more movement.

4 Make a Third Painting

Do not make a drawing this time. Look carefully at the first and second paintings to paint in the shapes. This is good training for the eye. You are looking at shapes and mass instead of lines. Work directly, taking no more than a half hour to complete the painting. Use a large brush to make each section quite wet before painting. Connect shapes and mingle colors, keeping to light and middle values this time. Most of the petals should be out of focus and should blend into a wet background in many places. With each consecutive painting you have the chance to correct and improve the design. Be spontaneous and work quickly. You might want to repeat the exercise several times with different subjects. Don't be afraid to paint a series of one subject. It can be a good learning experience.

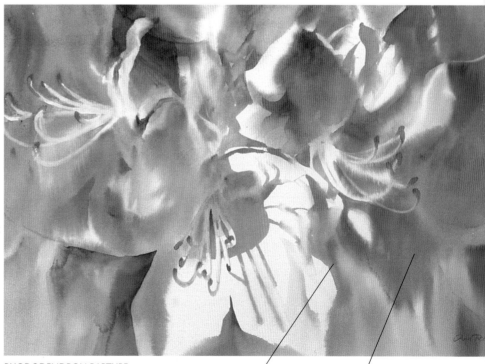

RHODODENDRON RAPTURE
Arches 140-lb. (300gsm) cold-pressed paper
14½" × 21½" (37cm × 55cm)

Better edge here.

Background colors mingle and flow well.

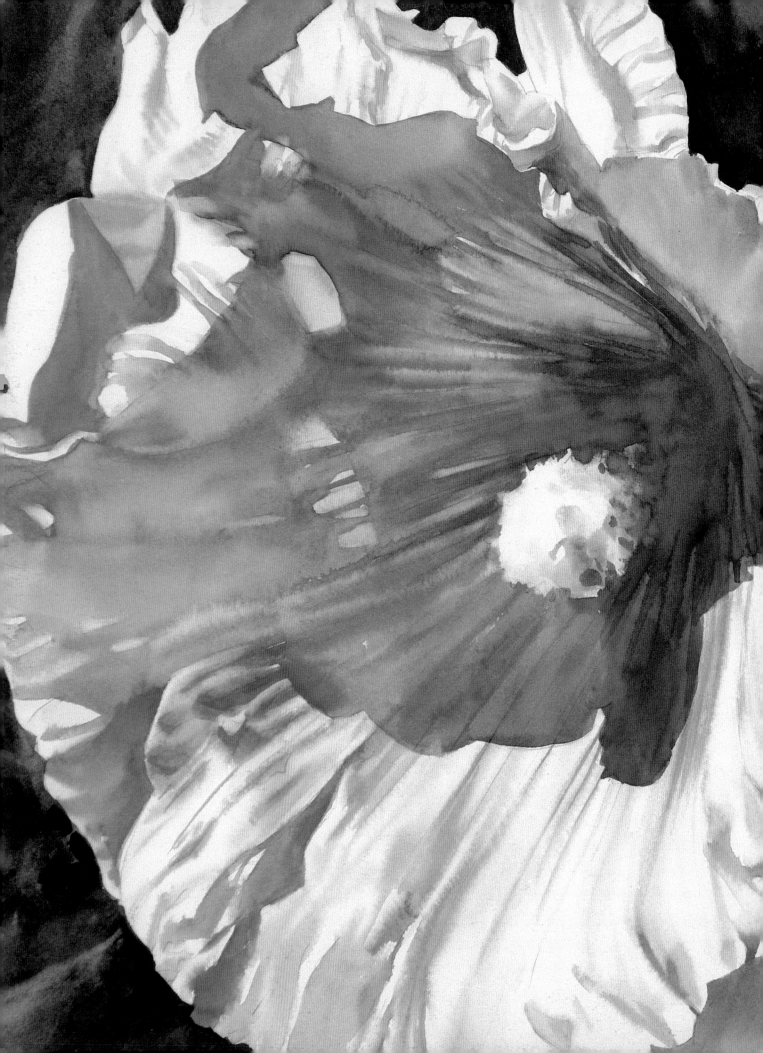

PART TWO

Assemble the Pieces: Step by Step

HARMONIOUS HOLLYHOCKS
Waterford 140-lb. (300gsm) cold-pressed paper
14½" × 21½" (37cm × 55cm)
Collection of Carl and Susie Chilson

Getting Started Painting Close-Focus Flowers: Amaryllis

Painting flowers with a close point of view allows you to work creatively with a traditional subject. You might wish to develop a partial or totally abstract statement. Let your intuition be your guide, and don't be afraid to give in to your creative side. Set aside preconceived notions about painting perfect, pretty flowers in watercolor. Think instead about making a good painting, good shapes and patterns, and painting what excites you. Look for ways to express emotions, mood, drama and peace, rather than just painting flowers. The content and quality of your work will grow from the experience.

MATERIALS LIST

Paper
Waterford 140-lb. (300gsm) cold-pressed

Palette
New Gamboge
Raw Umber
Antwerp Blue
Permanent Rose
Quinacridone Magenta
Aureolin

Brushes
Flats
¼-inch (6mm)—use for small areas
½-inch (12mm)—use for mid-size areas
¾-inch (19mm)—use to wet areas and to paint large areas
(or use the brushes of your choice)

1 Study Photos and References
Begin by looking through photos. When working from photos, select only the most pleasing shapes and composition; a small part of the image could be enough. This editing and planning phase is important. Choose a unique point of view. Leave out unnecessary details.

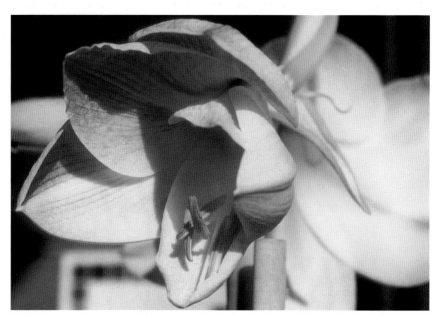

Cropped reference photo.

Transfer Your Drawing to Watercolor Paper

Cover a piece of tracing paper, cut to the size desired, with graphite (a soft lead pencil). Smudge the surface with a tissue to evenly distribute it and wipe off any excess.

For clean handling, cover all the edges of the paper with invisible tape.

Place your drawing where desired on the watercolor paper. Then place the homemade carbon paper between the two, graphite side down. Trace over the lines of your drawing, bearing down enough to make light guidelines. The carbon paper can be reused many times. Add more graphite as needed.

2 Make a Simple Drawing

There is no substitute for good drawing and the sense of proportion you learn along with it. Try making your drawing on tracing paper and transfer it to watercolor paper when it satisfies you. If you choose to draw directly on the watercolor paper, be careful not to damage the surface with any erasures.

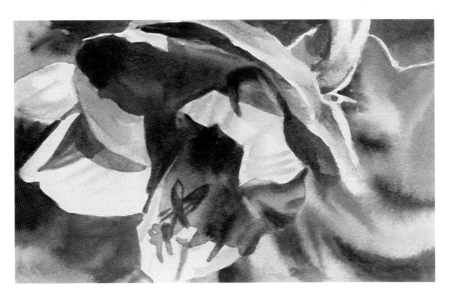

3 Make a Value Sketch

Make a small sepia or black watercolor value sketch to plan values and shapes. Don't rush this stage to get to the fun of painting.

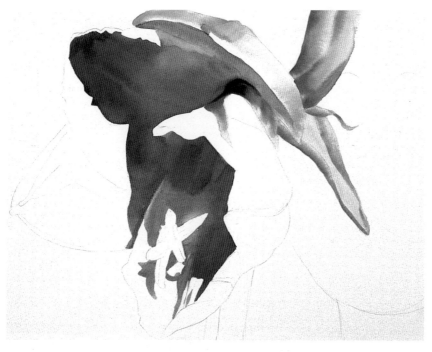

4 Begin With the Large Center Shadow

Start with the middle values, at the center, top. Use a large brush to paint the entire center shadow as one shape. Wet the whole area and mingle some greens (New Gamboge, Raw Umber and Antwerp Blue) into the pinks (Permanent Rose and Quinacridone Magenta) for interest. Paint around the stamens carefully with a smaller brush. Blend the shadow shape into the top petal and include the bud next to it, mixing in some Aureolin for a pale yellow-green. Charge in some darks fairly soon to help balance the values.

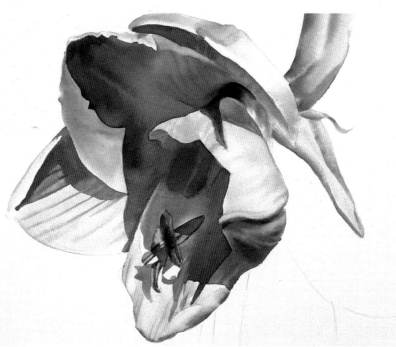

5 Paint the Other Petals

Continue painting in stages, remembering to mingle colors, soften edges and use enough pigment. Paint the other petals, adding details (linear indications along the petals) with a small brush, and define the stamens.

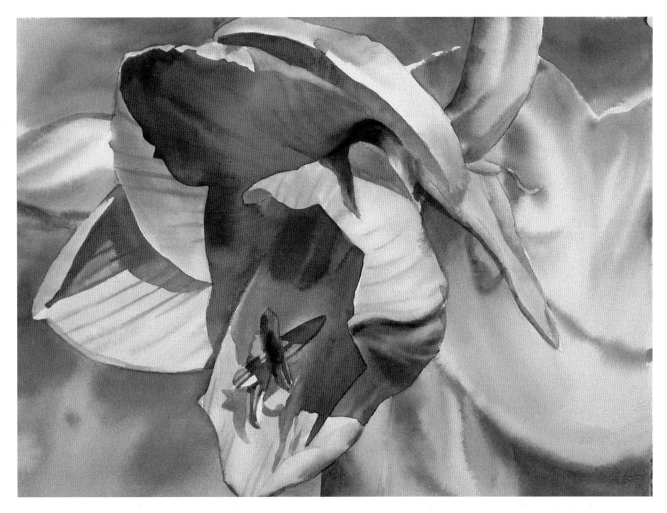

6 Complete Flowers and Add Background

Paint the light petals on the right and the background with a large brush. Work the background around and into the flowers. Keep these large petals quite light in value and mingle colors. Use Antwerp Blue, New Gamboge, Permanent Rose and Quinacridone Magenta. Repeat some of the flower colors in the background for unity. Let the background and flower merge edges in places.

AMARYLLIS
Waterford 140-lb. (300gsm)
cold-pressed paper
10" × 15" (25cm × 38cm)

High-Key Floodlight Effect: Hollyhock

The dictionary defines "floodlight" as "artificial illumination of high intensity, usually with a reflector that causes it to shine in a broad beam. Flood—to cover or fill."

High-key paintings give a feeling that the whole subject is bathed in an even illumination of light from overhead. The contrast is greatly reduced, creating softer edges. Because there are fewer hard edges, there is more movement. With this kind of lighting, it is beneficial to link shapes, providing a rhythm through the painting. Think of this lighting as if you were looking at things through a filter. You actually are doing just that; the atmosphere acts like a filter. With floodlighting, it is possible to see the more subtle colors that can be obliterated by a harsher light. Be sure to make color an important element; look for the subtle colors, especially in the shadows. A high-key painting can be somewhat moody and mysterious. It is likely to be found on a hazy, atmospheric day. It's as if you are looking at things through a thin veil.

MATERIALS LIST

Paper
Waterford 140-lb. (300gsm) cold-pressed

Palette
Aureolin
New Gamboge
Permanent Alizarin Crimson
Raw Sienna
Antwerp Blue
Permanent Rose
Raw Umber
Cadmium Red Purple
Winsor Green

Brushes
Flats
 ½-inch (12mm)—use for small areas
 1-inch (25mm)—use for large areas
Round
 no. 10—use for small areas
Blender
 1½-inch (38mm)—use to wet areas
Scrubber
 small fritch scrubber
(or use the brushes of your choice)

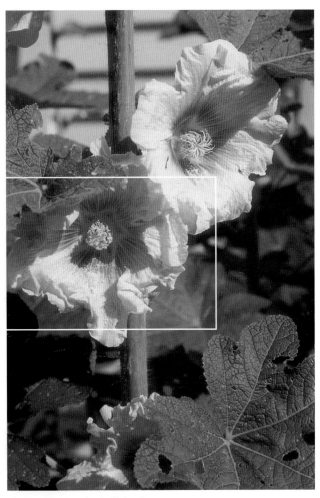

Photo reference for hollyhock.

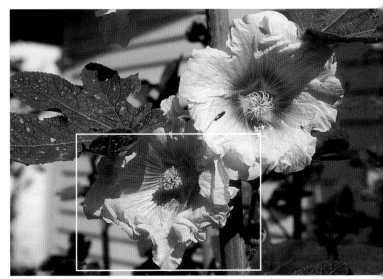

Photo reference cropped for better shapes.

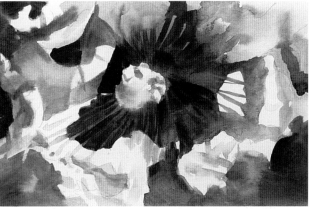

1 Complete the Drawing
Avoid too much detail and emphasize good shapes in your drawing, linking them when possible. You may want to make the drawing on tracing paper and transfer it to the watercolor paper when finished.

2 Value Sketch
Make a simple three-value sketch to plan the painting.

3 Begin Painting
Wet an area in the center of the flower a little larger than you need with your blender. Use a small brush to charge the area with Aureolin and New Gamboge, letting them mingle on the paper. Add darks of Permanent Alizarin Crimson and Raw Sienna. These can be added while the yellows are still wet. Paint a few deep accents with harder edges after the area has dried. Also work on the petals on the lower left, mingling Antwerp Blue, Permanent Rose and New Gamboge.

4 Develop Lower Left Petals

Paint in the pale pink of the petals using a small brush with Permanent Rose and Antwerp Blue, leaving white paper for the veins. Paint around the white areas carefully. Soften some edges using a clean, wet brush. You can clean up any ragged edges with a stiff bristle brush such as the fritch scrubber and blot with a tissue.

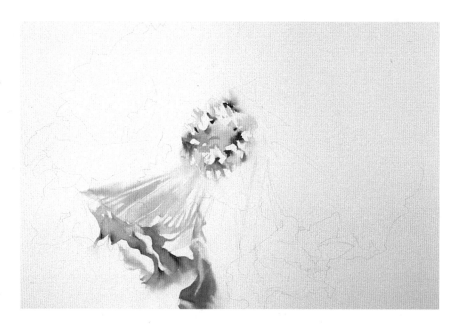

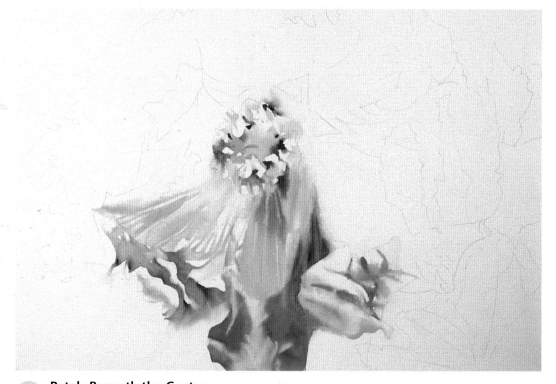

5 Petals Beneath the Center

Wet the whole area of petals beneath the center, even over part of the center with your blender. This will prevent any hard edges. Paint the deep yellow using New Gamboge, Raw Sienna and Raw Umber down toward the petals with a large brush, changing color along the way. Soften some edges and lift whites for the veins with a clean, thirsty brush and tissue.

Carry over to the right with minglings of Antwerp Blue, Permanent Rose and New Gamboge near the petal edges.

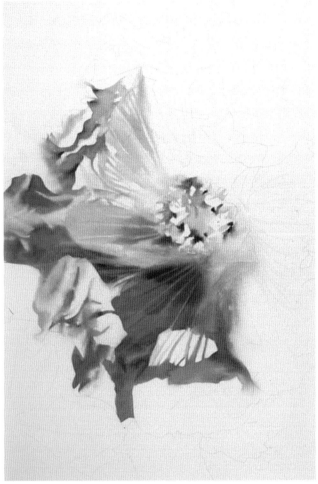

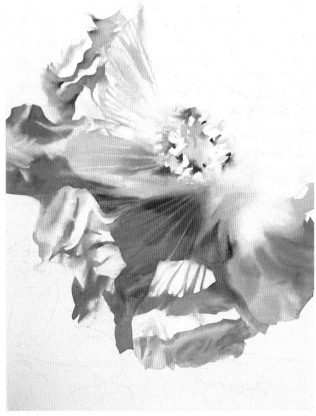

6 Paint Center Shadow

Turn the painting on its right side so gravity will make the paint move away from the center. Wet the large shape, including some of the already painted area so it will blend together. Then charge with Permanent Rose, Permanent Alizarin Crimson, Cadmium Red Purple, Antwerp Blue and New Gamboge using a large brush. Soften edges and mingle colors.

While the paint is damp, lift the light veins with a small brush. Blend these into the highlight on the petal where the veins are pink. Once dry, clean the veins with a small brush and glaze them with New Gamboge. Make the veins darker near the center and vary the yellows, adding Raw Umber.

7 Refine Right Side

With the painting still on its side, clean up edges and veins if needed. Add any subtle shadows as a glaze. Add the green near the center with a small brush, using Antwerp Blue and New Gamboge by pre-wetting first and then blending edges. Paint the midtones of the top petal with Permanent Rose and Antwerp Blue and finish to its edge.

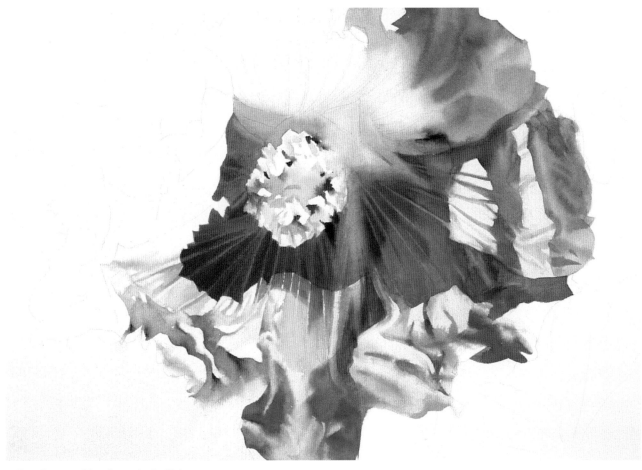

8 Center Shadow, Left Side

Turn the paper upright again. Wet the area that will become shadow before charging with paint. Then paint in the shadow using a large brush with Cadmium Red Purple, Permanent Rose, Raw Umber and Raw Sienna. Make the paint rich and deep. Remember, it will dry lighter! Again, pull out veins with a small thirsty brush or scrubber, using its edge. Glaze with New Gamboge and Raw Umber. Blend edges. For impact, add the darkest applications of Antwerp Blue and Raw Sienna just before the area dries.

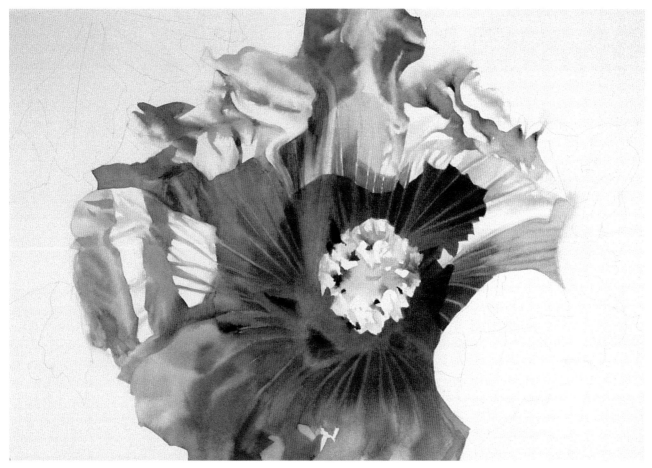

9 Develop Top Petals

Turn paper upside down. Wet the portion above the flower's center and just over the nearest painted parts. Paint rich darks near the center using the same shadow colors as in step 6, blending into the neighboring darks. Add the small triangles of green using a small brush with Antwerp Blue and New Gamboge, blending into the yellow veins around them.

Then paint out to the edge of the paper, mingling Permanent Rose and Antwerp Blue. Lift out veins. When dry, add a glaze of Raw Sienna and Raw Umber over the veins and near the center for shadow. Also paint mid-tones to the left of center with Permanent Rose, Raw Umber, New Gamboge and Antwerp Blue.

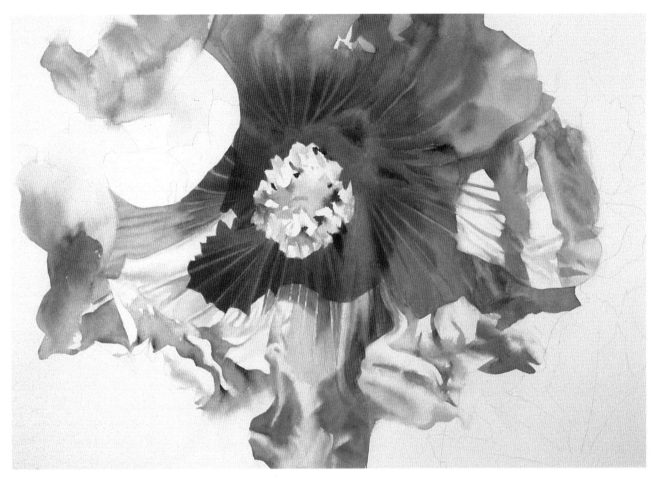

10 Paint Outer Left Petals
Turn paper right side up. Wet each outer petal area and float in mingled colors using a large brush with Permanent Rose, New Gamboge and Antwerp Blue.

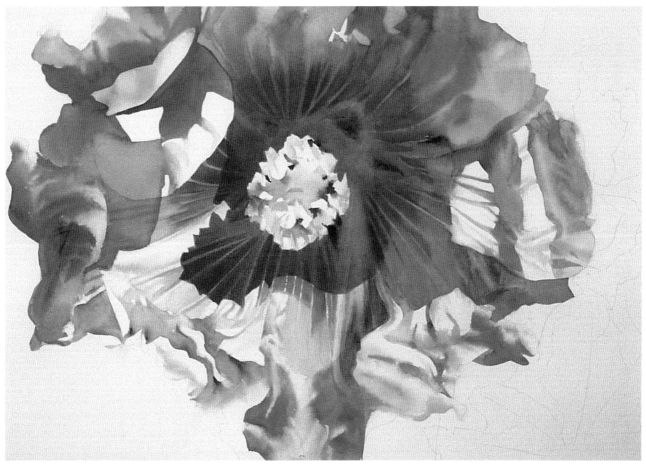

11 Add Shadows on Left Petals

Paint Permanent Rose, Antwerp Blue, Permanent Alizarin Crimson and New Gamboge with a large brush, allowing colors to mingle in the darker areas. Before the wash dries, charge in more color if the area needs greater intensity.

12 Upper Right Corner

Wet the upper right corner of the painting with your blender. Paint the suggested flower in the background using a large brush with Permanent Rose, New Gamboge and Antwerp Blue. Make this a light midtone to keep it from drawing too much attention from the large flower.

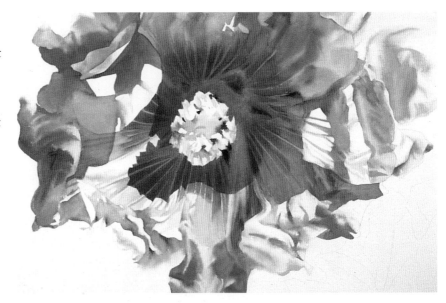

13 Changes to Lower Bottom Petal

I was not pleased with the bottom petal shape. If you have any changes to make, this is a good time to do so. Even though you try to plan well, things sometimes fall short. But they can be fixed. Carefully scrub out the area to be changed. When totally dry, re-wet and paint again with the new shape. Soften edges and mingle color. You can also lighten the veins above the center by lifting gently. This gives a greater feeling of dimension to the petal. Refine the center too, glazing with midtone minglings of New Gamboge and Raw Sienna. Add deep red accents with Permanent Alizarin Crimson and Cadmium Red Purple.

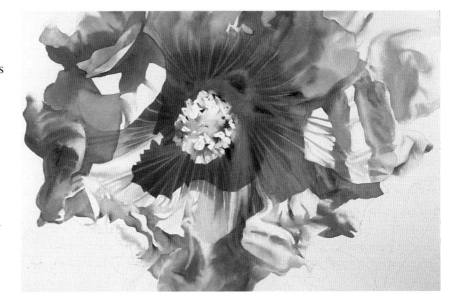

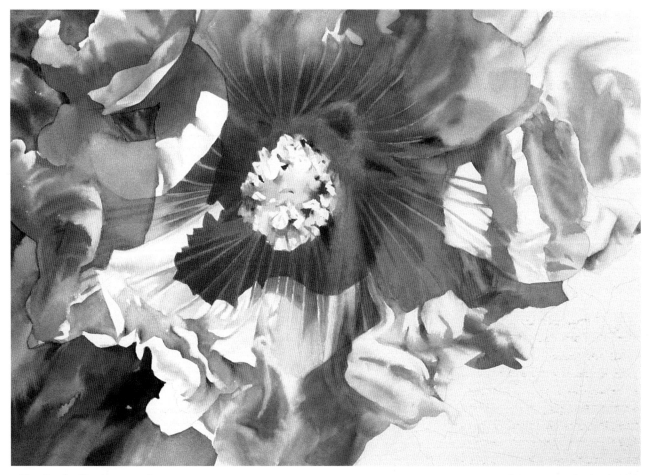

14 Begin Background

Wet the background at upper left and float in New Gamboge, Winsor Green, Cadmium Red Purple, Antwerp Blue and Raw Umber using a large brush. Let the colors mingle. Work down the side, wetting each area as you go. The petal edges that touch the edge of the paper are convenient places to end a wash. Then finish the bottom left corner, stopping at the lower petal.

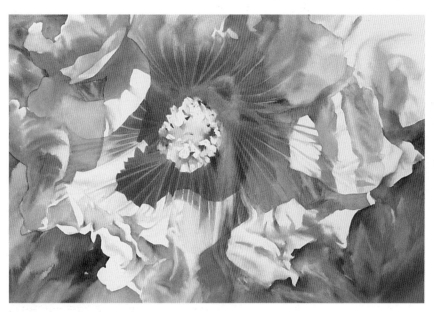

15 Paint the Remaining Background

In the same manner as step 14, work carefully around the petals of the right side. Soften some areas into the flower petals to avoid a cutout look to the flower. Let the same color and value flow between the flower and background, linking them together.

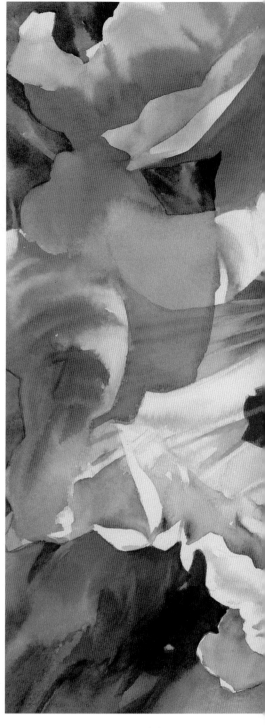

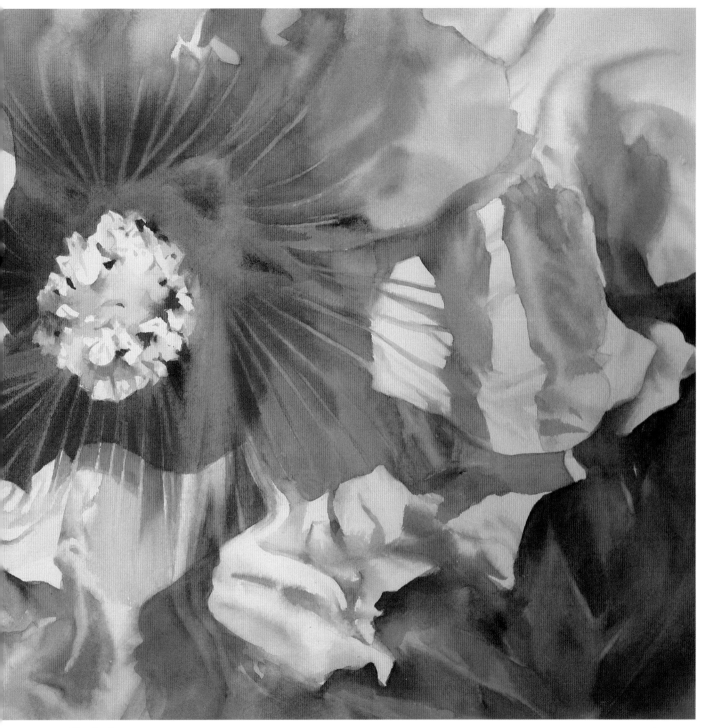

16 Refinements

Glaze over the background if it needs to be darker, using the same colors as in step 15. Blend the edges. At the upper right corner, subdue the petal in the background with a glaze of Permanent Rose, Antwerp Blue and New Gamboge. This should create a feeling that this petal is behind the large flower.

SUMMER SPLENDOR
Waterford 140-lb. (300gsm)
cold-pressed paper
15" × 22" (38cm × 56cm)

Backlight Effect: Peony

Backlighting creates a sort of halo effect with the light behind the subject. Contrasts may be great between light and dark areas. Backlighting reduces the amount of detail we see. Most of the light areas of flower petals and foliage appear around the edges and where they are thinnest. Their translucence allows light through. The thicker portions, or areas where petals overlap, will be darker because they are too thick to permit the light to shine through. Again we have an opportunity to link shapes together, making use of the value patterns. The edges within the flower form will be fairly soft and the outer edges harder. There may be more subtle color in the light areas. This type of lighting can be moody or dramatic, and can occur at any time of day, depending on how you choose to handle it. Both staining and nonstaining transparent colors are appropriate. Place the subject between you and the light source.

MATERIALS LIST

Paper
Waterford 140-lb. (300gsm) cold-pressed

Palette
New Gamboge
Permanent Rose
Antwerp Blue
Quinacridone Gold
Winsor Green
Cadmium Red Purple

Brushes
Flats
½-inch (12mm)—use for small areas
¾-inch (19mm)—use for mid-size areas
1-inch (25mm)—use for large areas
Blender
1½-inch (38mm)—use to wet areas
(or use the brushes of your choice)

Photo Reference for Peony
Don't feel that you must include the whole photo or the whole flower if you paint from life. Use a mat to look for the most pleasing shapes. Connecting two or three sides of the subject to the edges of the paper at some point can make for a better design.

1 Complete the Drawing
Keep the marks just dark enough to see. Edit any elements that are not necessary, are poor shapes or are too detailed. Connect the shapes, forming patterns of light and dark. Combining shapes to simplify forms can strengthen the design.

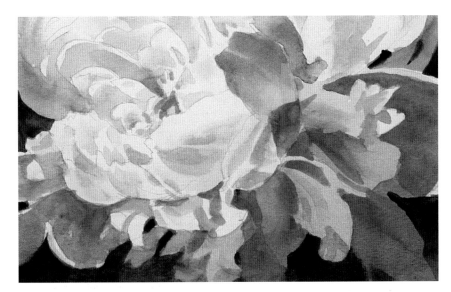

2 Make a Value Sketch

It is helpful to work out the placement of the values before painting. There should be a dominance of one—light, middle or dark—to set the mood of the painting. The sketch will only take a few minutes and can be quite crude. No need to get into detail.

3 Paint the Upper Left Petals

Start by wetting the upper left petals with clear water and your blender. Leave the white edges of the petals dry and paint around them. Feel free to turn the paper around when painting. You may find this easier if you are painting on a large sheet. Use a large brush to charge the wet paper with New Gamboge and Permanent Rose, letting them mingle. Keep the value quite light. This outer edge is where the sun illuminates the flower most. Introduce a touch of Antwerp Blue for a cool to balance the warms. Soften some edges, especially those of the white highlights. Soften them on the inside edge and leave the outer edge hard.

4 **Continue Upper Petals**
Using the same colors as in step 3, connect the rest of the light upper petals to those just painted. You can do this while the first area is still wet. If it has dried, re-wet the last part on the right side and the new area together with the blender, and charge with paint. This will avoid any unwanted hard edges.

5 **Introduce Darker Middle Values**
Just below the light back petals already painted, charge in some darker color using your mid-size brush with Quinacridone Gold, Permanent Rose and Antwerp Blue. They will mix to a purple-green. Be sure to wet the adjacent edge of the petals above to blend the two areas together. Soften some edges and paint around any whites or lights.

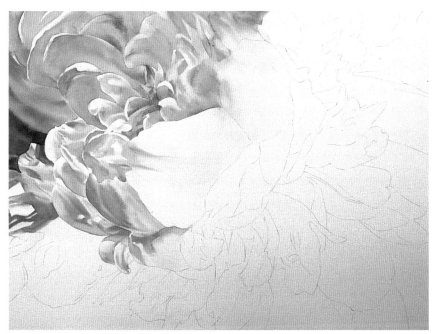

6 Paint the Curved Under-Petals

These petals are in both light and shadow. Use the blender to re-wet the previous wash edge to blend color. Then wet the petals you can comfortably paint in one wash and charge in Quinacridone Gold, Antwerp Blue and Permanent Rose with a large brush, letting them mix in places to form a lavender and aqua. Save some whites, especially at the highlight edges. Charge in slightly darker values as the wash begins to dry.

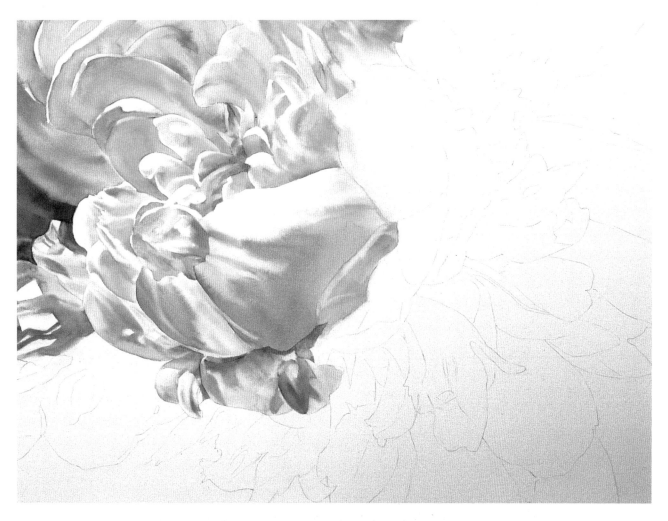

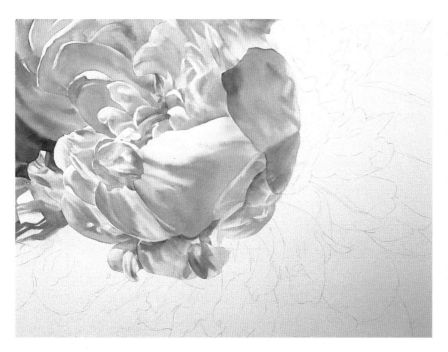

7 Paint Large, Translucent Petals

These petals have some light shining through them. The outer edge on the left will appear fairly dark against the light petals beyond. The combination of lights and darks will give them form, making them seem to turn. Wet the whole shape with the blender and use a large brush to charge New Gamboge at the base and lower edge to imply light glowing through. Mingle Antwerp Blue and Permanent Rose to form a variety of pinks, lavenders and blues. Keep the top outer edge fairly dark.

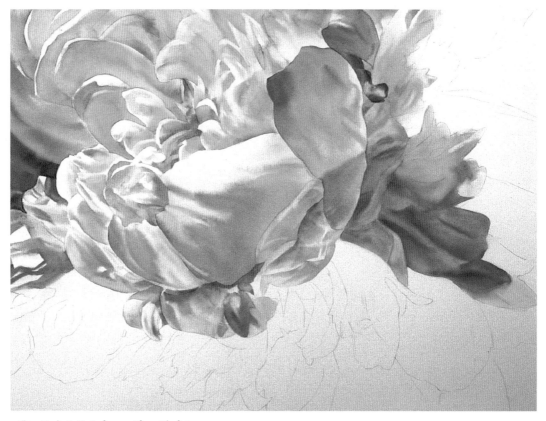

8 Paint Petals on the Right

Paint the petals that are in shadow adjacent to step 7 with a large brush, using the same colors as before, including Quinacridone Gold. Make these washes a bit darker in value, especially at the lower edge and just above the darker curled petal just completed.

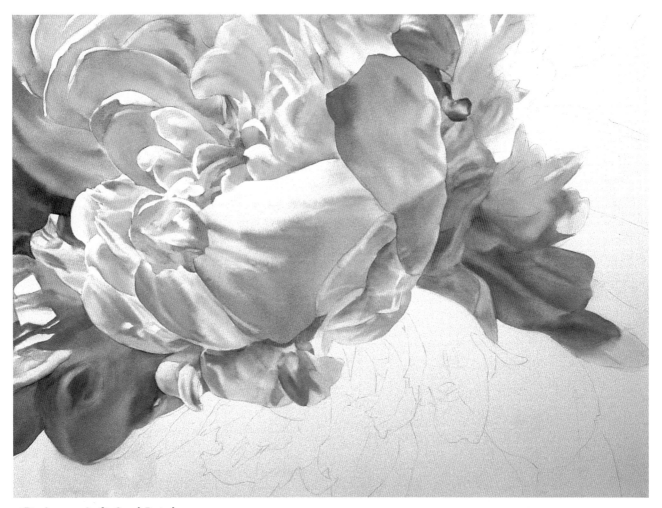

9 Lower Left Cool Petals

Use your blender to wet over the previous cool colors on the left side to blend and wet the petals under that area. Charge with Antwerp Blue, Permanent Rose and a touch of New Gamboge using a mid-size brush. Keep the value darker than that above it.

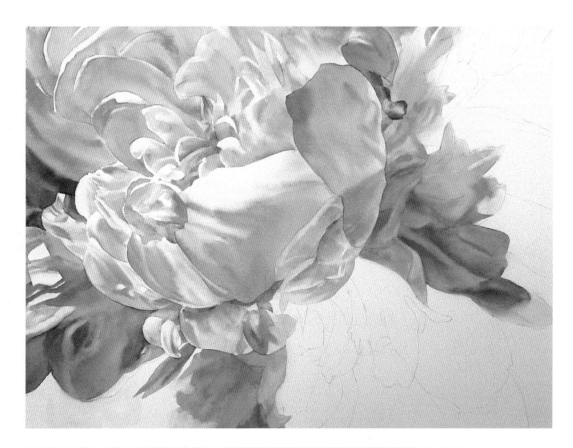

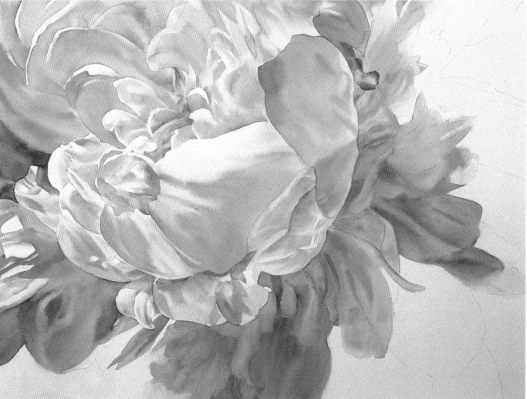

10 Work Around the Bottom

Use the same colors as in step 9, but in a deeper value. Charge darks in toward the end, as moisture begins to dry. Paint carefully around the petals above with a large brush.

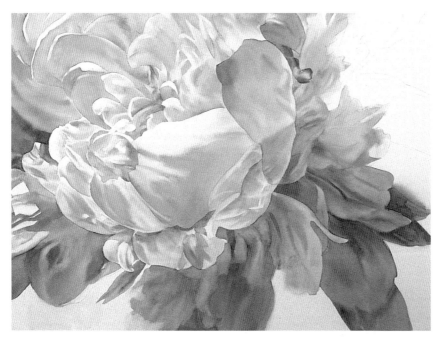

11 Paint Lower Right Petals

First deepen the small petal just above this section. It needs to be darker. Do this by applying a glaze of the same colors already there (New Gamboge and Permanent Rose) with a large brush.

Then wet the large petal shapes below with your blender and charge in rich color (Antwerp Blue and Permanent Rose at the bottom right and a bit of New Gamboge near the top of the petals), letting them mingle. These petals are in shadow. Try to get them dark enough.

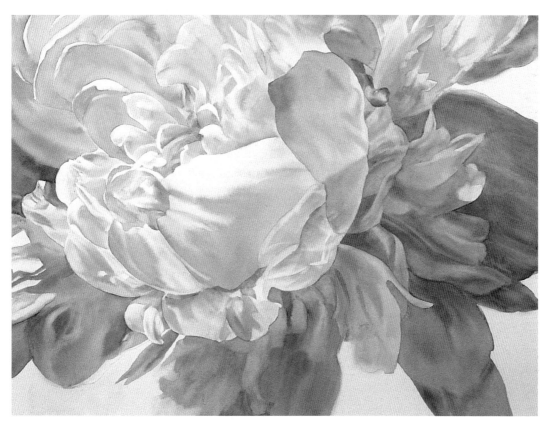

12 Paint Upper Right Petals

With the same colors as in step 11, richly paint the upper right petals by wetting the whole area first with the blender, then charging in colors using a large brush. Keep the paint moving and mingling freely.

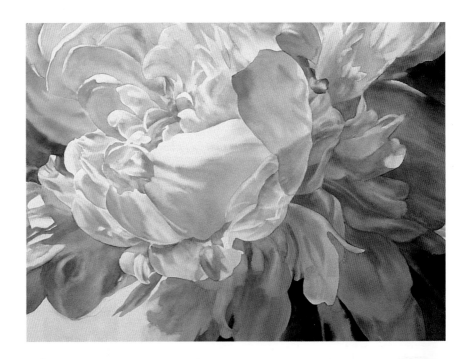

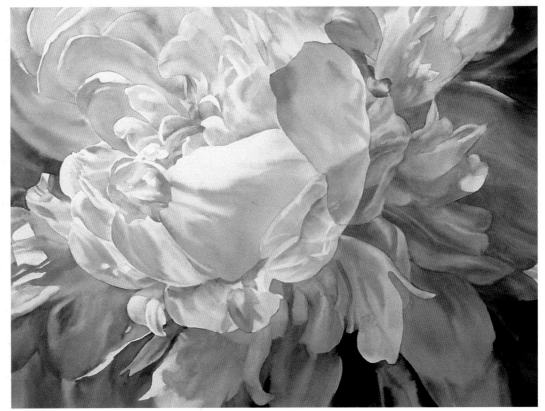

13 Complete the Background

Mingle Winsor Green and Cadmium Red Purple with the previously used colors and apply to pre-wet sections of the background with a large brush. Paint carefully around the petal shapes, softening some edges so the flower and background merge in places. The majority of shadow is on the right, so keep colors rich and dark in value in those areas.

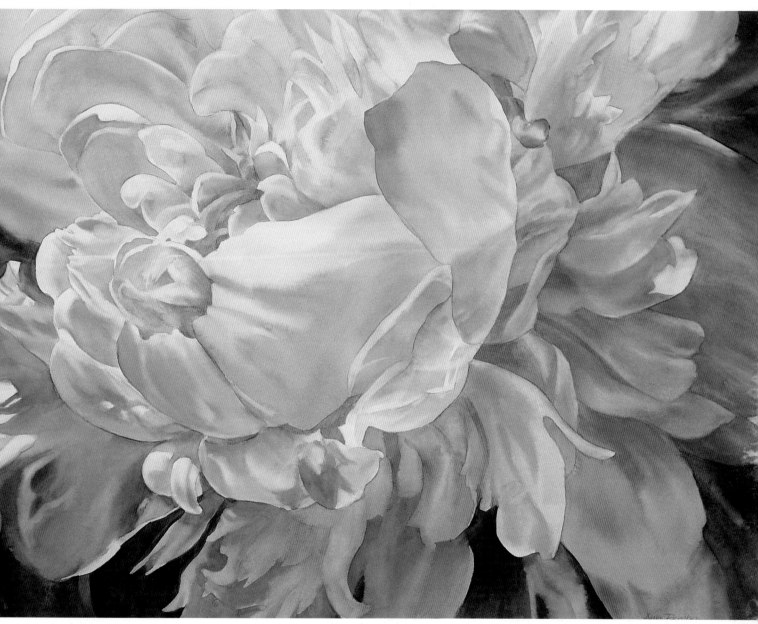

14 Refinements

Deepen any sections that seem too light; the left side of the background needs to be deeper to make the highlights of the petals above it stand out. Adjust edges, lift any lights as needed and add subtle color by glazing where absolutely necessary.

CELEBRATION
Waterford 140-lb. (300gsm)
cold-pressed paper
21½" × 29½" (55cm × 75cm)

High-Contrast Spotlight Effect: Gladiola

A simple dictionary definition of "spotlight" is "a projected spot of light used to illuminate brilliantly a subject on stage; a light designed to direct a narrow intense beam of light on a small area; something that illuminates brilliantly."

The spotlight effect produces a high contrast of values. It is a fairly harsh type of lighting and will wash out the most subtle colors. This can be very dramatic and suggests a feeling of great energy. Many hard edges are formed, and it is necessary to design the shapes well, subduing some of the hard edges for variety by connecting them with similar colors, value or texture. Connect shapes together, forming patterns of light and dark. The staining transparent pigments can be useful in such a painting to produce rich darks, shadows and jewel-like colors.

Spotlighting is the kind of light you find on a bright day with a clear atmosphere. Remember to look for reflected colors in the shadow areas; even though they appear dark when contrasted with the lights, they receive reflected light, too. Warms as well as cools will be in both the shadows and the lights as a result of reflection.

MATERIALS LIST

Paper
Waterford 200-lb. (425gsm) cold-pressed

Palette
New Gamboge
Antwerp Blue
Permanent Rose
Raw Umber
Winsor Green
Cadmium Red Purple

Brushes
Flats
 ¼-inch (6mm)—use for small areas
 ½-inch (12mm)—use for mid-size areas
 1-inch (25mm)—use for large areas
Blender
 1½-inch (38mm)—use to wet areas
(or use the brushes of your choice)

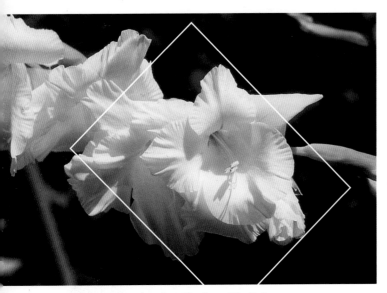

Photo Reference for Glorious Gladiola
I really turned the photo to find the shapes I liked, using a small mat to help me isolate the forms. Be creative when working with photos: turn them, cut them if it helps, use a mat to mask parts out. Here I zoomed in on one flower, even though there is a whole stalk of them.

1 Complete the Drawing
Link shapes, make patterns, simplify and consider what effects are produced by the light as you draw your flower.

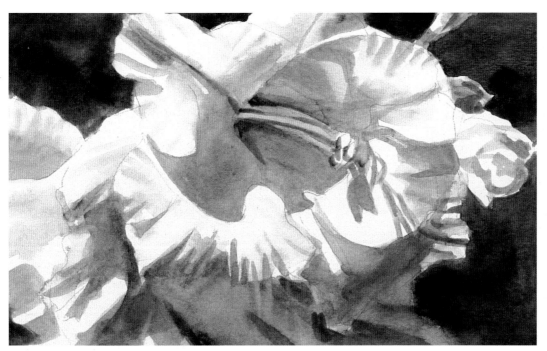

2 Make a Value Sketch
Make a simple value sketch to work out the patterns of shapes.

3 Begin Painting at the Top
Use New Gamboge, Antwerp Blue and Permanent Rose to paint light value washes over the top petal after wetting the paper there with your blender. Let colors run down and blend into the center of the flower. Soften most of the outer edges to nothing with a large, wet brush.

Paint around the stamens using a small brush with New Gamboge, adding some Antwerp Blue to make green near the center. Just under the stamens at the center, mingle some Raw Umber to the green to make a rich brown.

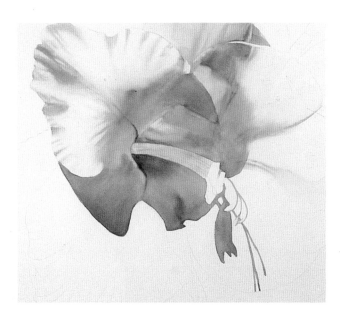

4 Paint Around Flower's Center

Begin with the frilly outer edges of the upper left petal. Wet the whole petal and use a mid-size brush to float in small minglings of the colors you've been using, making a purple mix to emphasize the "frills." Soften edges with a wet brush to keep color where you want it. Re-wet the petal near the center, and charge in Antwerp Blue and Permanent Rose for the shadow where the petal curves. Immediately paint the deep pink vein Permanent Rose with a small, well-pointed round brush or a flat with a good knife-edge.

Add New Gamboge near the very center with a large brush to create a glow. Continue working the shadow down below the stamens, wetting first to keep everything connected and mingle. Glaze over the area around the stamens you already painted. Use a small brush to paint around the end of the stamens and down into their shadow, merging this wash with the shadow above.

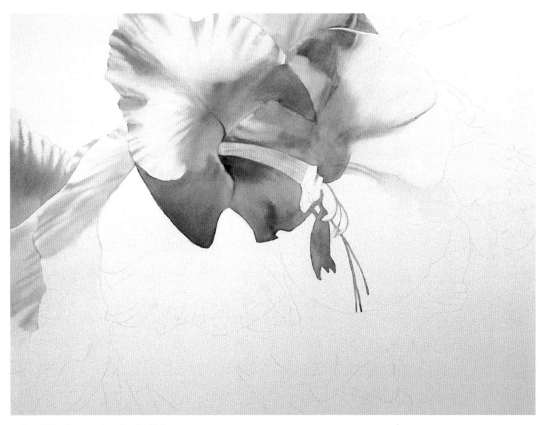

5 Work on the Left Side

Wet the petals on the left side and use a large brush to mingle Permanent Rose, Antwerp Blue and New Gamboge. Keep the darker blue and lavender at the top third of each petal where there is a curve, and place the New Gamboge at the base of the petal. Use both hard and soft edges.

6 Continue to Develop Left Side

Using the same colors as in step 4 and a large brush, work down the side, wetting as you go. Save whites and make these washes a bit deeper in color. The yellow should produce a feeling of sunlight glowing through the petals.

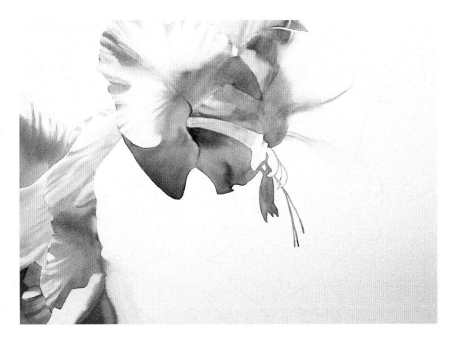

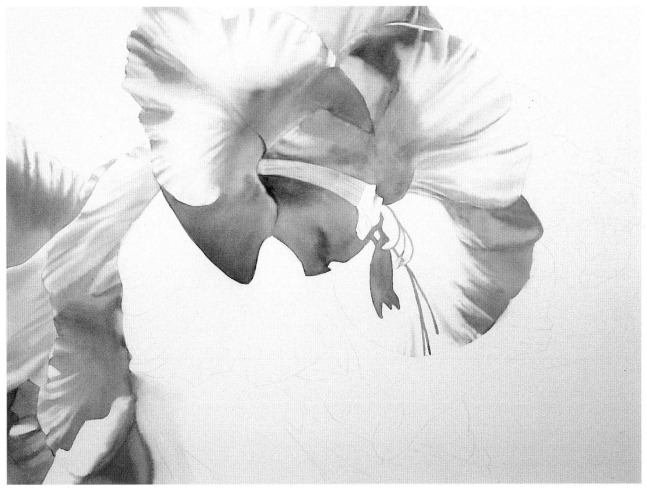

7 Develop Central Petals

Carefully re-wet over the right side of the center and onto the petals on the right with your blender. Use a mid-size brush to charge in the same colors as in step 4, mostly on the outer edges and a few connecting shadows. Soften edges. Make the shadows of the lower petal darker than those above it.

8 Paint Bud, Leaf and Stem

Use small and mid-size brushes to wet the bud shape and paint with light washes of New Gamboge, Permanent Rose and a bit of Antwerp Blue and Raw Umber for darks. Mingle colors and make hard and soft edges. This bud is in the light so it should not be too dark. Above the bud wet the leaf shape and paint with New Gamboge, Raw Umber, Antwerp Blue and a touch of Winsor Green and Permanent Rose for the darks. Use these same colors to paint the small stem shape at the top right, varying colors to show shadow and highlight.

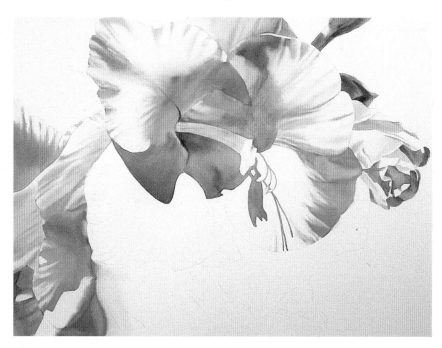

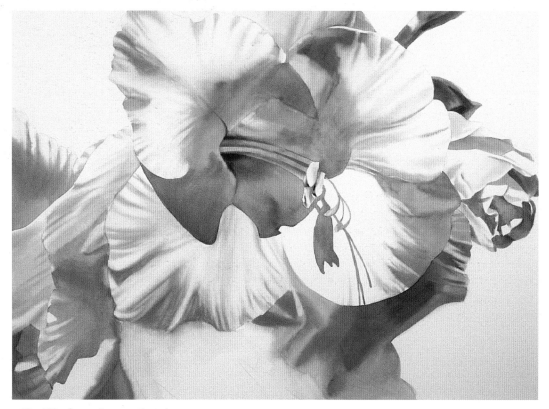

9 Work on Lower Petal

Wet the petal with the blender and apply Permanent Rose, Antwerp Blue and New Gamboge using a mid-size brush, mingling them for color variation and shadow near the frilly edges. Lift whites with a thirsty brush. Wet below the bottom of the petal with the blender to make the paint diffuse. This will merge into the next section. Save enough whites.

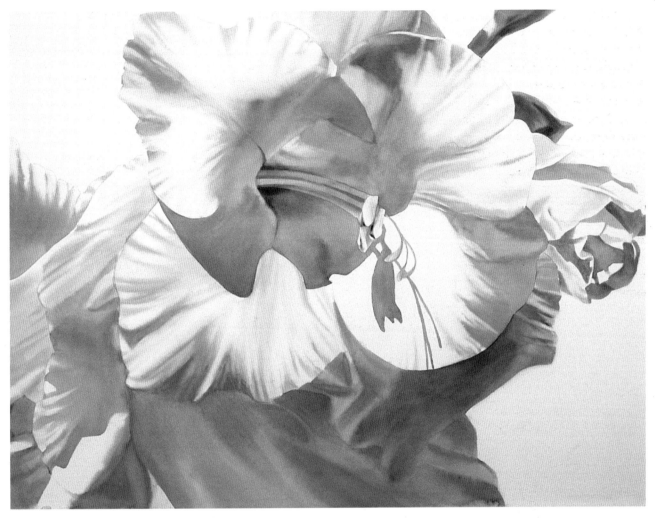

10 Finish the Center

Use your blender to re-wet around the center and include the stamens. Deepen and define the stamens using a small brush with New Gamboge, Antwerp Blue and Permanent Rose. Then paint the ends of the stamens with Permanent Rose and a bit of Antwerp Blue.

Wet the petal shape under the lower right petal of the large flower with a large brush and float in Permanent Rose, New Gamboge and Antwerp Blue. Charge in darks as the area loses moisture. Use the blender to soften the leading edge on the left to blend it with the next wash.

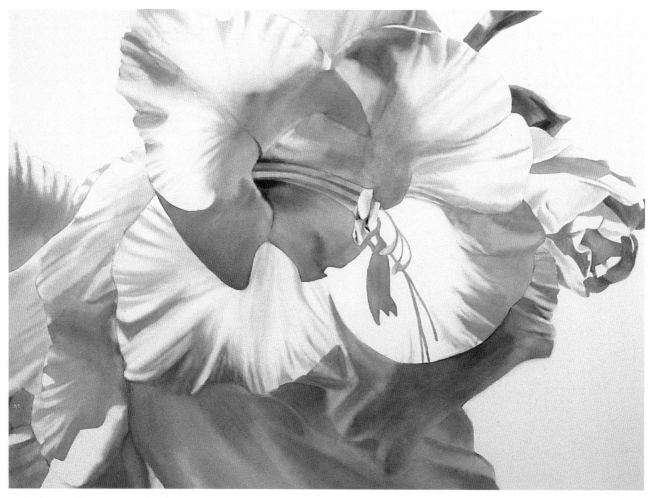

11 Paint the Lower Shadow

Wet the whole shape, including the outer edges of the previous washes for blending. With the colors used in step 10 and a large brush, charge in color, adding darks as the wash loses moisture. Make this shadow dark enough. Include a bit of New Gamboge in your mingle to make the shadow glow.

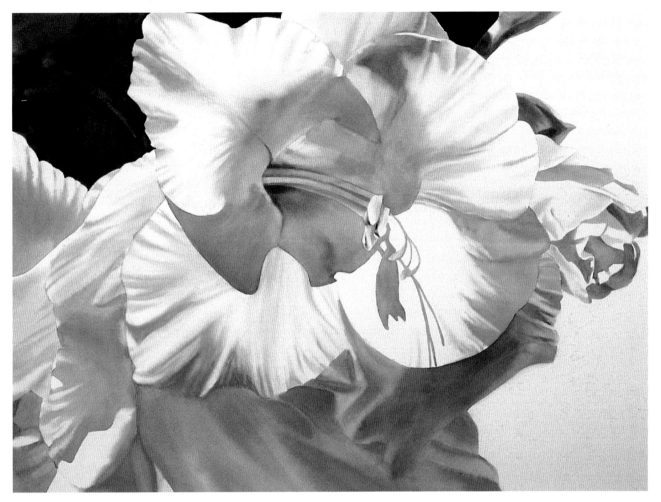

12 Begin the Background

Wet the top background shapes and charge with Winsor Green, Cadmium Red Purple, Permanent Rose and Raw Umber using a large brush. Make it quite dark, using plenty of pigment. Be careful with the Winsor Green. You might want to mix it with one or several of the other colors before applying it to the paper. Generally, it is best to mix colors on the paper, but this color is so harsh it needs toning down. Once painted in a mixed form it can still be mingled with more color.

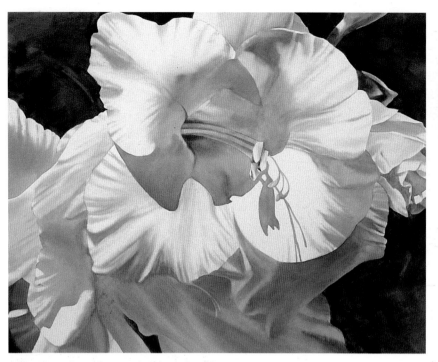

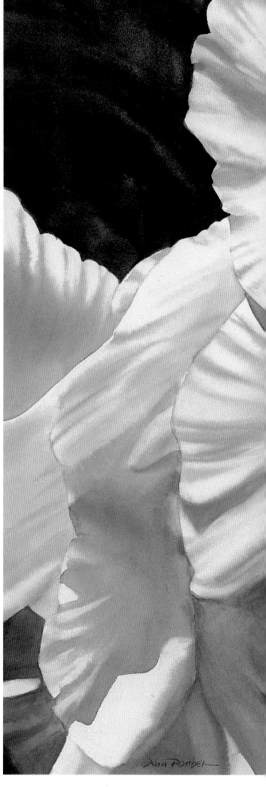

13 Develop the Background

Continue on down and around the flower shapes to complete the background, mingling with the same colors as used in step 12.

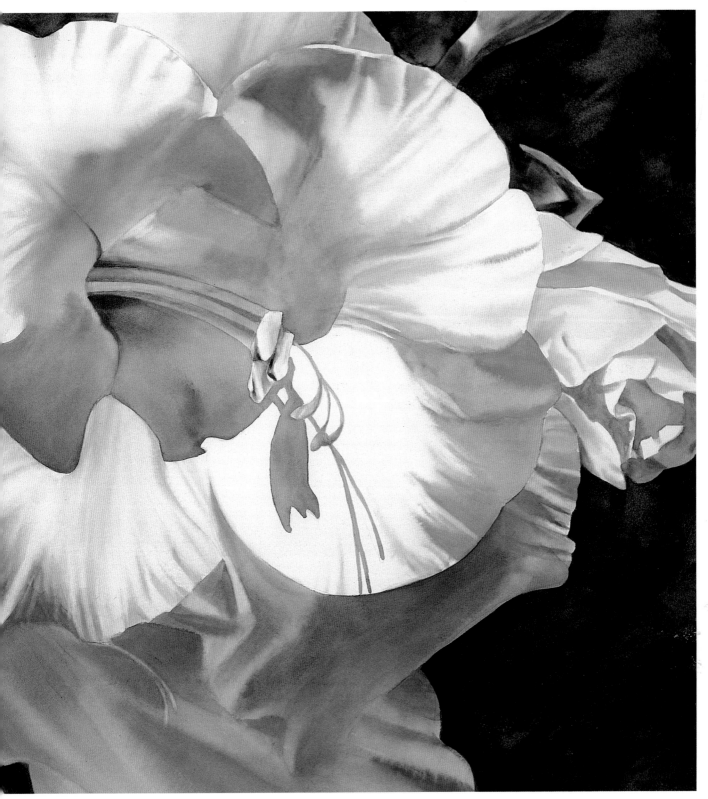

14 **Refinements**
Clean up the edges, glaze where needed and lift color where too dark. If, like mine, your background needs to be darker, add a glaze of the same colors as used in steps 12 and 13. While this is wet, slightly lift color with a soft brush in the upper left, right and lower right corners to give a suggestion of foliage.

GLORIOUS GLADIOLA
Waterford 200-lb. (425gsm)
cold-pressed paper
21½" × 29½" (55cm × 75cm)

Painting on a Smooth Surface: Lotus

This demonstration begins with painting light midtones over the whole painting. With this type of surface, it is important at first to get paint down over the whole painting. Use what you've learned about smooth paper from part 1 (see pages 68-69) to develop a flower and background.

If your paper curls as you build up layers of paint, let the paint dry completely, then turn the paper over, clip it to a board and cover the back of the paper with clear water. Let it dry before removing the clips and turning it right side up to resume painting.

MATERIALS LIST

Paper
Strathmore 500 Series high plate bristol board

Palette
New Gamboge
Permanent Rose
Antwerp Blue
Aureolin Yellow
Raw Umber
Cadmium Red Purple
Winsor Green

Brushes
Flats
 ½-inch (12mm)—use for small areas
 ¾-inch (19mm)—use for mid-size
 areas
 1-inch (25mm)—use for large areas
Blender
 1½-inch (38mm)—use to wet areas
(or use the brushes of your choice)

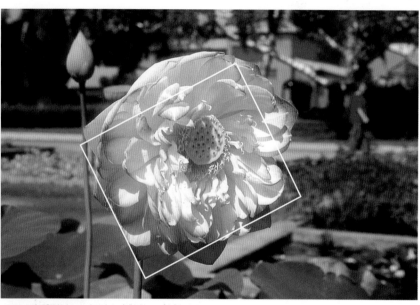

Photo Reference
This flower has many petals and is quite complex. It also has many unusual combinations of colors: pink-edged petals, many color changes within the petals, speckles and a most unusual center. It is a good subject to paint playfully.

1 Complete the Drawing
Edit down to an interesting arrangement of shapes. Try to simplify by linking several petals or shadow shapes together. Keep it quite light on this surface; it is hard to erase.

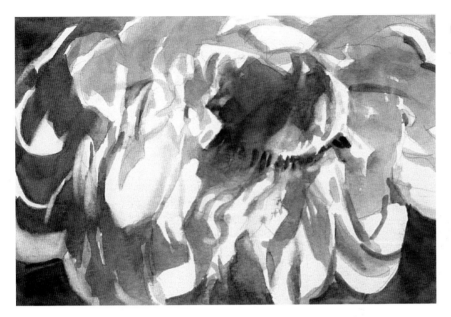

2 Make a Value Sketch
Make a simple value sketch to work out the patterns of light and dark shapes.

3 Begin Petals
Wet the petals to the upper left of the center with a large brush. Mingle light washes of New Gamboge, Permanent Rose and Antwerp Blue using a mid-size brush. Soften some edges and work down around the side of the center. Pull out lights, such as the stamen forms around the center, with a small, damp brush while the wash is wet. This will make softer edges. Charge in darks around the center while the wash is wet.

4 Paint the Center

Wet the whole center with your blender and paint quickly with New Gamboge and Aureolin Yellow, adding Permanent Rose and Antwerp Blue to make darks. Brown is made using New Gamboge, Permanent Rose and Antwerp Blue. Vary the colors throughout. Use the corner of a flat brush or the tip of a round to drop in dots made of Permanent Rose, New Gamboge and Antwerp Blue before the area dries. They should be soft edged. Also paint the top right petal connected to the center.

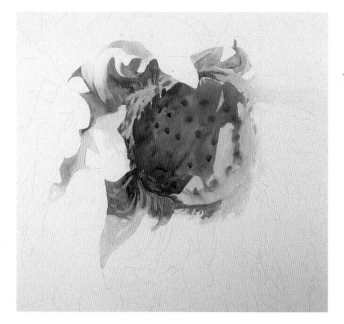

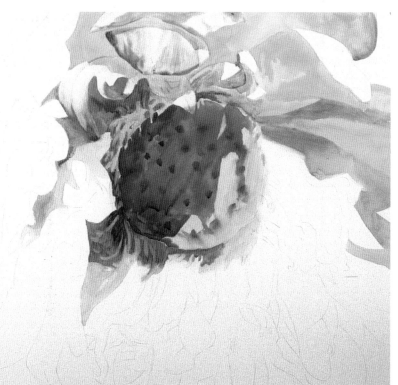

5 Develop Petals

Wet each section with your blender. For the top pink petals mingle Permanent Rose and Antwerp Blue. Mingle New Gamboge, Permanent Rose and Antwerp Blue for the yellow petals on the right. Lift any lights, or paint around them. Paint the broad shapes quickly with a large brush so the wash will stay wet.

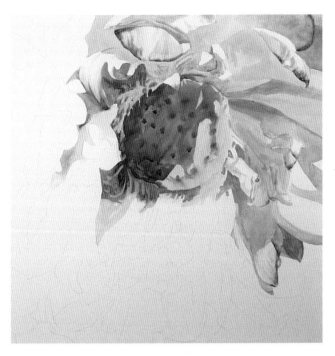

6 Work Down the Right Side

Continue from petal to petal, mingling the colors with mid-size to large brushes as used in step 5. Charge darks before dry. Some petals should have a deep pink edge softened on the petal's inside.

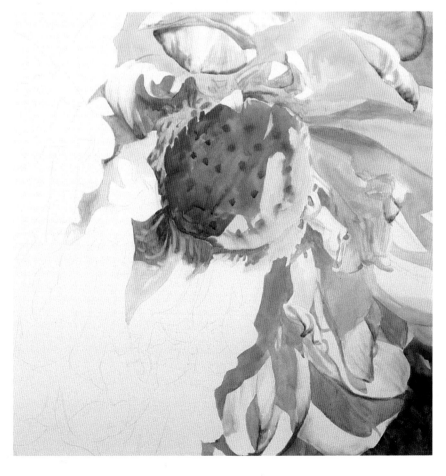

7 Continue Down the Right Side

Use the same colors and methods here as in step 6. Save and lift whites. Utilize edge variety. For the lower right background use Antwerp Blue, Raw Umber, New Gamboge and a bit of Permanent Rose, Cadmium Red Purple and Winsor Green.

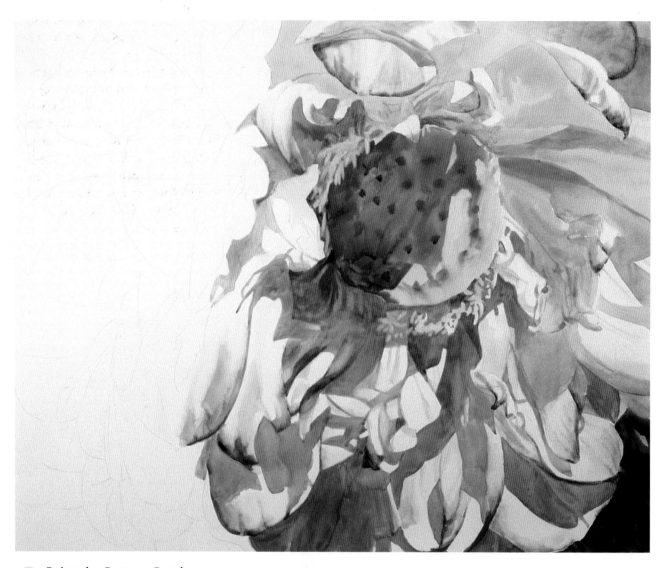

8 Paint the Bottom Petals

Using the same colors and methods as in steps 6 and 7, paint the petals below the center. Deepen some areas to express the shadow of the petals. Vary colors between cool and warm.

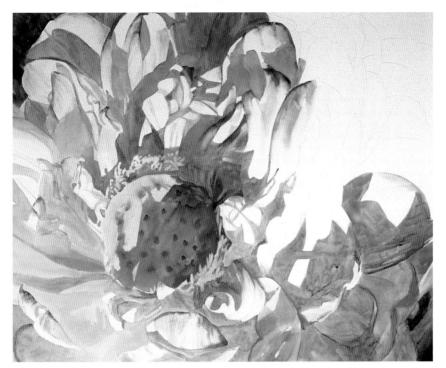

9 Begin Upper Left Petals

Turn the paper upside down for ease. Wet the paper in sections using your blender, and charge with color using a large brush, painting around the whites. For the lavender areas mingle Antwerp Blue and Permanent Rose. Make the petals at the upper left (lower right here) using Raw Umber, New Gamboge, Aureolin Yellow and Antwerp Blue, with Permanent Rose at the outer edges. Suggest the foliage at the upper left corner (lower right here) with New Gamboge, Raw Umber and Antwerp Blue and a bit of Winsor Green.

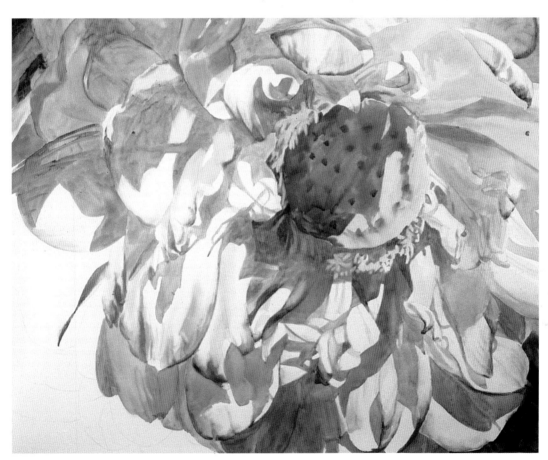

10 Work Down the Left Side

With the paper right side up, continue down the side of the flower, wetting the paper in sections and mingling the same colors as above with a mid-size brush. Mingle the orange areas with Permanent Rose, Aureolin Yellow, New Gamboge and Raw Umber.

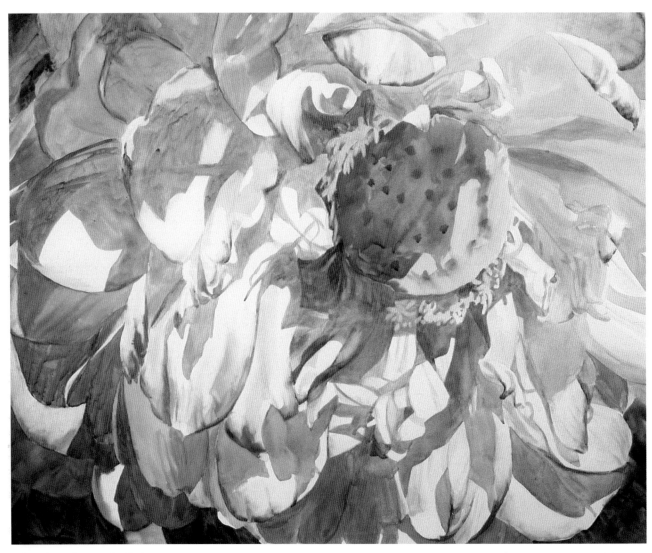

11 Develop Left Side

Continue painting the petals on the left side of the flower with a large brush and the same colors and methods as in step 10. The lower left corner of the background should be quite dark for contrast. Paint this with Antwerp Blue, Raw Umber, Permanent Rose and a bit of Winsor Green.

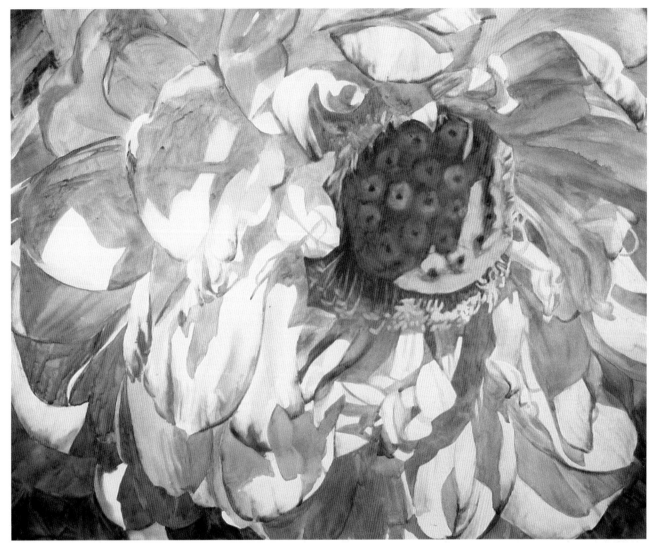

12 Work on Upper Right

Add more Permanent Rose and Antwerp Blue in the petals at the upper right. You will need to disturb the underpainting a bit as you apply more color. Keep the section you are painting juicy with paint, or it may streak.

Paint Aureolin Yellow over the whole center with a large brush, immediately adding a mixture of Antwerp Blue, Permanent Rose and New Gamboge to form a rich brown. Make it juicy. While wet, disturb the paint in little circles, using Aureolin Yellow and New Gamboge to form the center spots. Give some of the spots a dark center by adding some Permanent Rose. All of this should be soft edged, accomplished by working wet. If it gets too dry to finish, let it totally dry and re-wet it to complete. Deepen the stamen forms in the shadow to the left and below the center by painting around them.

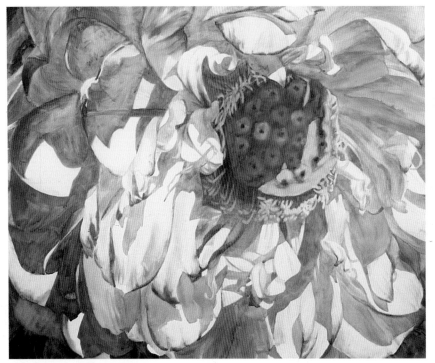

13 Work on Upper Left

Use more of the same petal colors to add another layer over the shadows on the left-side petals, moving from the top down using a large brush. These shadows need to connect and be quite deep in color. The secret to working a large area is to keep it wet and juicy with color. The color should not be too watery, or it will just lift the color already there.

14 Finish Lower Portion and Make Refinements

Intensify darks and shadows. Lift lights and clean up edges.

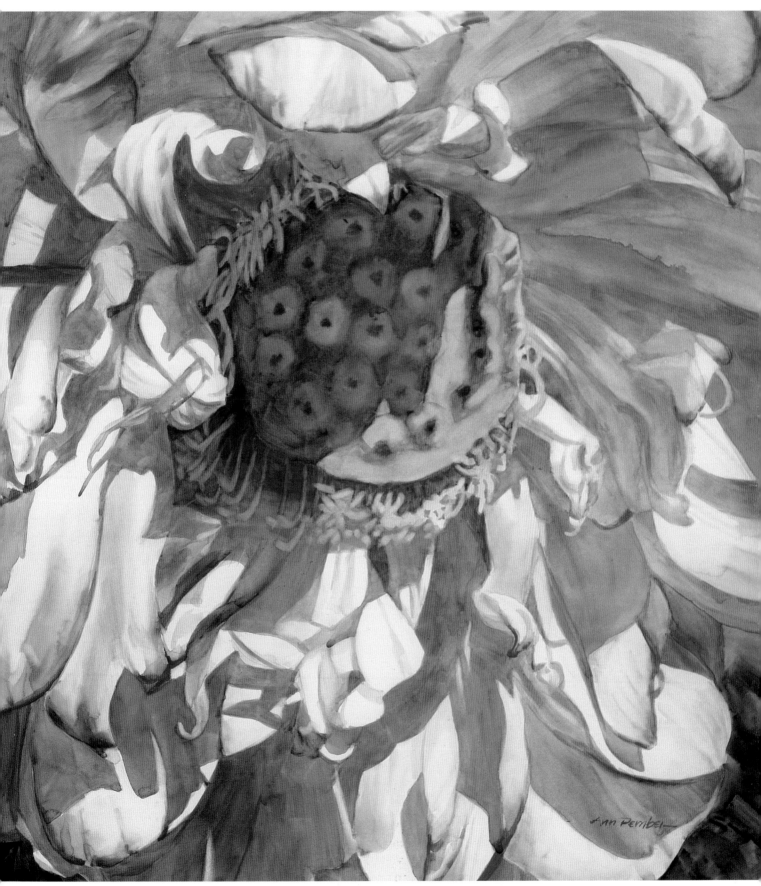

LOVELY LOTUS
Strathmore 500 Series high plate bristol board
21½" × 29" (55cm × 74cm)

Conclusion

I hope you are willing to try working with some of the ideas presented here. We are all individuals, so experiment to see what works for you. Take nothing stated here or anywhere else as your truth. Experience what that is for yourself. Every choice you make—colors, subjects, scale, lighting, techniques, tools, materials, point of view—will shape your individual style. Even mistakes can be enlightening. There is no need to agonize over your personal style; just trust your intuition.

Achieving excellence takes lots of practice. If you are dedicated to your art and give it constant attention, you will be rewarded.

Information is only helpful if you absorb it and use it. So I hope you will be persistent and take the time to paint regularly. Enjoy the process and really put something of yourself into your paintings.

Once your work has developed some consistency, try entering it in juried exhibitions to see how it holds up to that of your peers. Be prepared to receive rejection without personal attachment to the outcome. Believe me, over the years I have accumulated my share of rejection slips as well as accep-

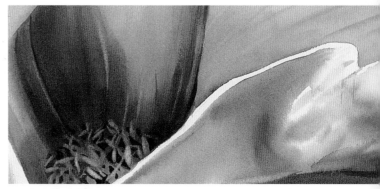

tances. Rejections bring disappointment, but I've learned to detach emotionally from them. The jury process is difficult, especially when there are many hundreds or thousands of entries. The jurors are forced to reject some very good work. They are also human and are affected by personal preferences, if only subconsciously. Accept critiques with careful consideration for valid remarks and then move on. Don't allow any rejection or remark to overly influence your work or halt your progress. Be true to yourself and your individuality.

Do not take my words in this book too seriously. There are no hard and fast rules in art, just our own individual form of expression and translation of life. We are all constantly changing. My art continues to change along with my choice of subject, palette and materials. That is part of the growth process. Don't cling to working only a certain way, or become entrenched in what is comfortable or easy. Stretch yourself by being open to new possibilities. You may be pleasantly surprised by where changes can take you. I fully expect and hope that my work will change again and again. I'd be disappointed if it didn't.

Most of all, enjoy the journey. It becomes your life: Make it special and sincere. The rest will follow. And remember, success comes in many forms.

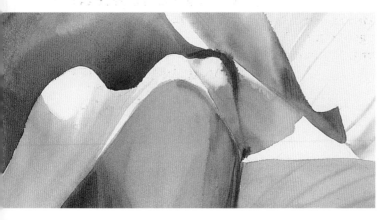

Glossary

Analogous Colors
Adjacent, closely related colors on the color wheel.

Backlighting
The subject is located between the viewer and the light source. This can be a dramatic point of view.

Bloom
A curled edge forms when an almost dry wash has water or wet paint introduced into or next to it. This can create interesting effects.

Charging Colors
While the surface is wet, apply paint with a brush. The pigment will float onto the surface, going wherever the paper is wet.

Complementary Colors
A color's opposite on the color wheel. Across the wheel from a primary color is a color made from the combination of the other two primaries.

Controlled Wet-in-Wet Painting
Wet the painting surface in sections and apply paint, allowing it to blend together on the surface.

Direct Painting
Apply a rich mixture of paint to a dry surface.

Glazing
Apply thin layers of transparent paint one over the other. Each layer must be dry before receiving a new layer of paint.

High-Key (Floodlight)
A dominance of light values; atmospheric, evenly lit.

Lifting Paint
With various tools or brushes, scrape, rub, moisten, blot or scratch to remove paint. This can be done dry or wet.

Low-Key
A dominance of dark values.

Mingling Colors
Wet the section of paper to be painted, then charge in the colors desired, letting them blend together. This is controlled wet-in-wet painting.

Monochromatic Color Scheme
Making use of the various tints or shades of one color.

Nonstaining Transparent Colors
These pigments have good clarity and lift easily. They produce beautiful glazes.

Opaque Colors
Chalky pigments that have a lot of body and hide other colors well. They can make mud when more than one is used in a mixture. They are somewhat sedimentary and can produce interesting textures by settling into the valleys of the paper texture.

Primary Colors
The three colors that cannot be obtained from mixing other colors: red, yellow and blue.

Secondary Color
A color obtained by mixing two primary colors in equal amounts.

Spattering
With water or paint on a brush or toothbrush, flick the bristles or tap against your hand to make drops hit the paper.

Spotlighting
A strong light directed at the subject. This creates deep shadows, high contrast and hard edges. It can be very dramatic.

Staining Transparent Colors
These are jewel-like colors with clarity and depth of color. They stain the paper and do not lift well. They produce lovely rich darks.

Value
The qualities of light and shade in the painting.

Wet-in-Wet Painting
Totally wet the whole surface and apply fresh paint, letting it blend together on the surface.

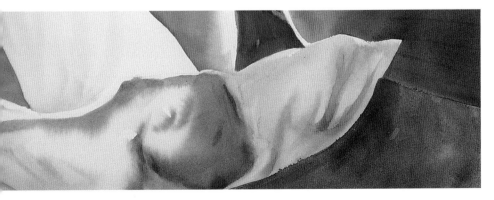

Gallery

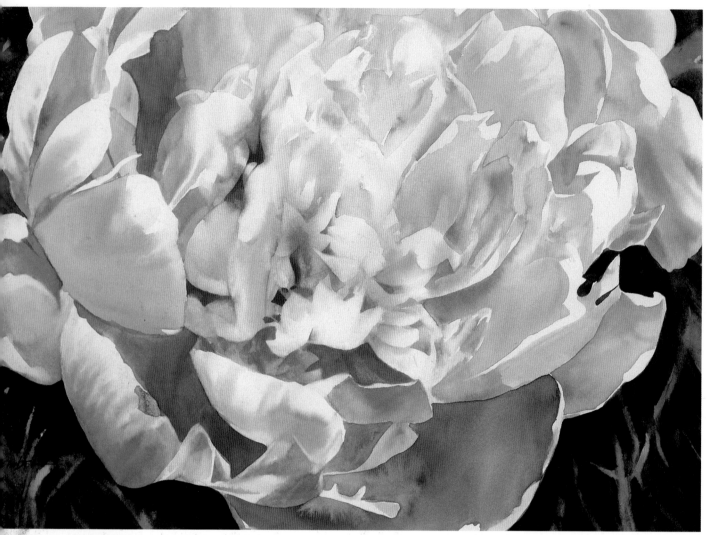

SUNNY PEONY
Waterford 140-lb. (300gsm) cold-pressed paper
14½" × 21½" (37cm × 55cm)

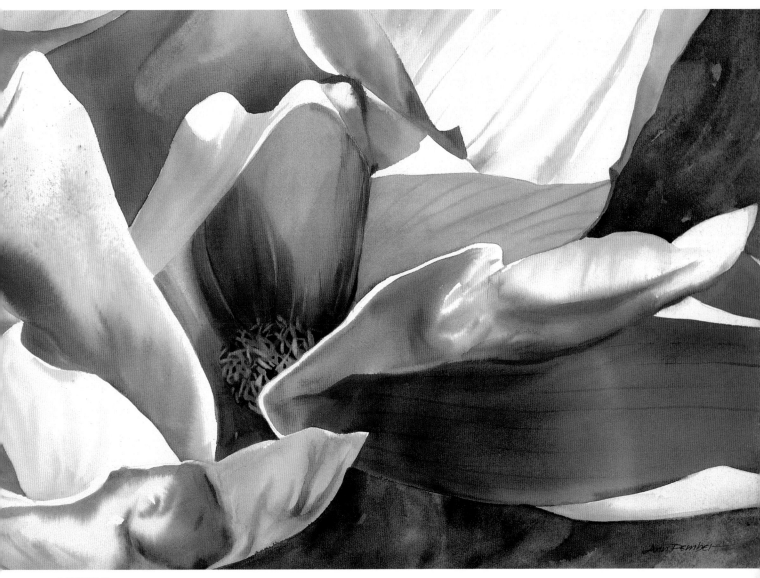

MAGNOLIA
Arches 140-lb. (300gsm) cold-pressed paper
14½" × 21" (37cm × 53cm)

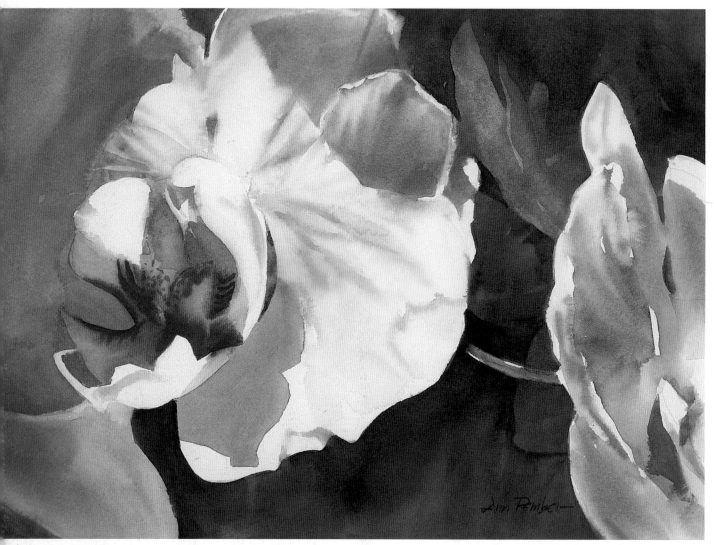

ORCHID
Kilimanjaro 140-lb. (300gsm) cold-pressed paper
10½" × 14½" (27cm × 37cm)

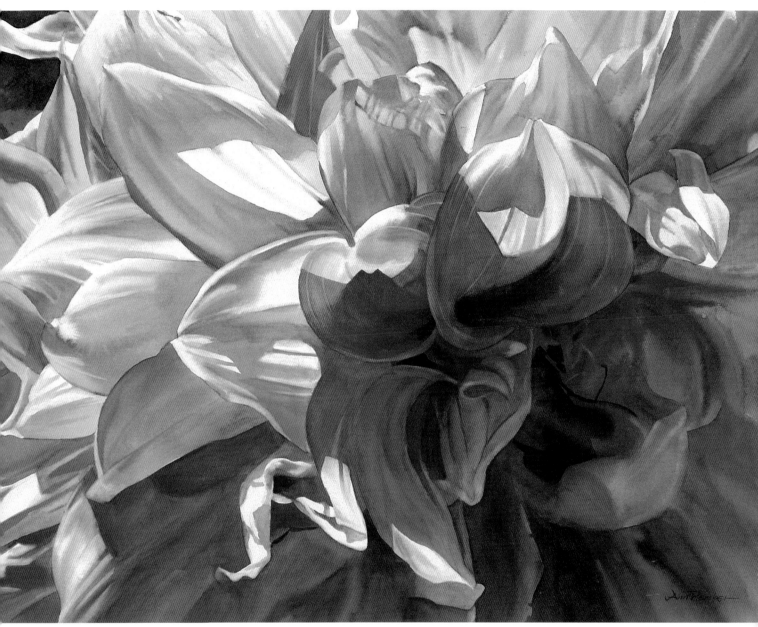

DYNAMIC DAHLIA
Waterford 140-lb. (300gsm) cold-pressed paper
21" × 29" (53cm × 74cm)

Index

A

Amaryllis, 74-77

B

Background, 46-51
 and flower, merging edges, 77
 See also Demonstrations, background
Backing board, 17
Backlighting, 53, 90-99
 phlox, 41-43
Begonia, 58-59, 69
Blending tools, 21
Blithe Begonia, 69
Blooms, 37
Bountiful Begonia, 69
Bristol board, 68-69
 painting on, 110-119
Brushes
 flat vs. round, 18-19
 types, 17
Bud
 hollyhock, 32-33
 shapes, creating pattern, 39
 See also Demonstrations, buds

C

Camera, 14
 for capturing light, 52
Celebration, 99
Center of interest, 56
Chemical reactions
 of pigments, 37
Color(s)
 background, 47
 books on, 26
 complementary, 25
 mingling, 30-33
 examples, 31
 mixing luminous, 22-27
 primary, 23
 secondary, 24
 two, 63-65
 See also Pigments

Color schemes, analogous, complementary or monochromatic, 62
Complementary colors, 25, 62
Composition
 designing, 54-57
 and editing photos, 15

D

Dahlia, 40, 44, 125
 lighting, 53
Damp-lifting, 38
Dazzling Dahlia, 10-11
Demonstrations
 background, 43, 48-49, 50-51, 65, 77, 87-88, 98, 107-108
 backlight effect, 90-99
 bristol board, painting on, 110-119
 buds, 41, 104
 darks, 43, 48, 51
 drawings
 detailed, 70
 simple, 75, 79, 90, 100, 110
 first washes, 48
 floodlight effect, 78-79
 leaves, 42, 104
 limited palette, 63
 linking shapes, 64
 mingling, 32-33
 petals, 32-33, 45, 76, 80, 83-86, 91-95, 97, 103-104, 111-112, 114-115
 photos and references, 74, 90, 100, 110
 shadows, 41, 51, 64, 82, 85, 106
 spotlight effect, 100-109
 stamen, 45, 76, 81, 102, 105, 112
 stem, 42, 104
 values, 58-61
 value sketch, 75, 79, 91, 101, 111
Design, elements of, 56-57
Direct painting, 28
Drawing
 simple, 75. *See also* Demonstrations, drawings, simple

transferring, 75
Drips, controlling, 16
Drops, for texture, 37
Dry-brushing, 29
Dry-lifting, 38
Dynamic Dahlia, 125

E

Easel, adjustable, 16
Edges
 hard
 avoiding, 92
 spotlight and, 100
 soft, 117
 softening, 91
 and cleaning, 80
 varying, 34-35
Exercises
 color mixing, 22
 loose painting, 70-71
 mingled colors, 31
Exhibitions, juried, 120

F

Floodlighting, 52
 high-key effect, 78-89
 vs. spotlighting, 53
Flower(s)
 centers. *See* Stamens
 circular-shaped, 40
 clusters, 40-43
 combined forms, 40
 conical-shaped, 40
 integrating, with background foliage, 50-51
 reason for painting, 12
 shapes, creating pattern, 39
 sources, 14-15
 See also Bud, Petals, individual names
Foliage, background, 47-51
 integrated with flower, 50-51
 patterns, 48-49
Fome-cor, 17

G

Gardens, visiting, 14
Gatorboard, 17
Gladiola, 100-109
Glazing, 29
 vs. mingling, 33
Glorious Gladiola, 108-109
Glowing Rose, 61
Gloxinia Gems, 12-13
Gloxinias, 12, 48-49
Gorgeous Gloxinia, 49
Grays, mixing, 25

H

Hallowed Hydrangea, 51
Hard edges, 34
Harmonious Hollyhocks, 72-73
High-contrast painting, 100-109
High-key painting, 78
Hollyhocks, 44, 72-73
 bud, 32-33
 floodlit, 78-89
 lighting, 53
Hydrangea, 40, 50-51
Hydrangea, 40

L

Leaves. *See* Demonstrations, leaves;
 Foliage
Lifting techniques, 38
 from bristol board, 68
 from toned paper, 66
Lightfastness rating, 20
Lighting, 52-53
 for photos, 14
 See also Backlighting, Flood-
 lighting, Spotlighting
Lost and found edges, 35
Lotus, 110-119
 spotlit and floodlit, 53
Lovely Lotus, 118-119

M

Magnolia, 123
Magnolia, 123
Materials, miscellaneous, 21
Mingling, 30-33
 with limited palette, 62
Mixing
 avoiding mud, 22
 grays, 25
 harsh colors, 107
 secondary colors, 24
Movement, 56
Mud, avoiding, 22

N

Nonstaining transparent pigments,
 26-27

O

Opaque pigments, 26-27
Orchid, 124
Orchid, 124

P

Painting
 large area, 118
 methods, 28-29
 See also Direct painting, Dry-
 brushing, Glazing, Mingling,
 Wet-in-wet painting
Painting surface, smooth, 68-69,
 110-119
Paints, 20
 See also Color(s), Pigments
Palette, 21
 limited, 62
 and mingling, 30
 and mixing colors, 22
 simple, 9
Pansies, 47
Paper
 curling, 110
 shape, 54
 tilted, 16
 toning, 66-67
 transferring drawing to, 75
 types, 17
 See also Bristol board
Patterns
 background foliage, 48-49
 creating, with flower and bud
 shapes, 39
 shapes and values as, 55
Peonies, 40, 122
 backlit, 90-99
 lighting, 52-53
Petals
 centers and, 40
 shapes, 40
 varied edges, 35
 See also Demonstrations, petals
Phlox
 backlit, 41-43
 in two colors, 63-65
Photos
 editing, 15, 110
 studying, 74
 tips, 14
 using mat to crop, 90, 100
 See also Camera; Demonstrations,
 photos and references
Pigments
 transparent, staining
 and nonstaining, 26-27
 for spotlight, 100
 transparent, vs. opaque, 22
 values, 54
Pink Phlox, 65
Point of view, 74
Prickly Pear Cactus, 44
Primary colors, 23

R

Radiant Rose, 66
Rhododendron Radiance, 71
Rhododendron Rapture, 71
Rhododendron Rhapsody, 70
Rhododendrons, 45, 70-71

Robust Rose, 67
Rose, 60-61, 66-67
Rule of thirds, 56

S

Scraping tools, 21
Scrubbers, 21
 and making changes, 86
Scrubbing. *See* Dry-lifting
Secondary colors, 24
Shapes
 flower and bud, creating pattern,
 39
 linking, 64
 paper, 54
 petal, 40
 simple, 58-59
 and values, as patterns, 55
Sketches
 for capturing light, 52
 See also Drawing; Demonstra-
 tions, drawings; Value sketch
Soft edges, 34
Spatter, 36
Sponge, cellulose, 21
Spotlighting
 high-contrast effect, 100-109
 vs. floodlighting, 53
Spray bottle, 21
 for texture, 36
Staining transparent pigments, 26-27
Stamens, 44-45. *See also* Dem-
 onstrations, stamens
Studio setup, 16
Style, developing, 9
Summer Splendor, 89
Sunny Peony, 122

T

Taboret, 16
Techniques
 lifting, 38
 painting, 28-29
Texture, 36-37

 with dry-brushing, 29
Toning, 66-67
Transparent pigments, 22, 26-27
 for spotlight effect, 100
Triads, 26-27

U

Underpainting, disturbing, 117
Unity, 56

V

Values, 54-55
 background, 46
 and shapes, as patterns, 55
 See also Demonstrations, value
Value sketch, 60-61, 75, 91
Val-u Viewer, 54-55
Variety, 56
 of edges, 34-35
Veins, 81

W

Water containers, 21
Wet-in-wet painting, 28
Wet-lifting, 38
Whites, composition and, 55
The Wilcox Guide, 20